BASICS

FILM-MAKING

01 Producing

Charlotte Worthington

D0221621

Academia
the environment of learning

An AVA Book

Published by AVA Publishing SA
Rue des Fontenailles 16
Case Postale
1000 Lausanne 6
Switzerland

Tel: +41 786 005 109
Email: enquiries@avabooks.ch

Distributed by Thames & Hudson
(ex-North America)
181a High Holborn
London WC1V 7QX
United Kingdom

Tel: +44 20 7845 5000
Fax: +44 20 7845 5055
Email: sales@thameshudson.co.uk
www.thamesandhudson.com

North American Support Office
AVA Publishing

Tel: +1 908 754 6196
Fax: +1 908 668 1172
Email: enquiries@avabooks.ch

English Language Support Office
AVA Publishing (UK) Ltd.

Tel: +44 1903 204 455
Email: enquiries@avabooks.ch

ISBN 2-940373-57-4 and
978-2-940373-57-4

10 9 8 7 6 5 4 3 2 1

Layout by modernactivity.com

Illustrations by Sam Piyasena

Production by AVA Book Production
Pte. Ltd., Singapore

Tel: +65 6334 8173
Fax: +65 6259 9830
Email: production@avabooks.com.sg

Gone
A film still from the short drama Gone.
Director: Oliver Graham
Producer: Camilla Boschiero
Photographer: Luigi Bertolucci

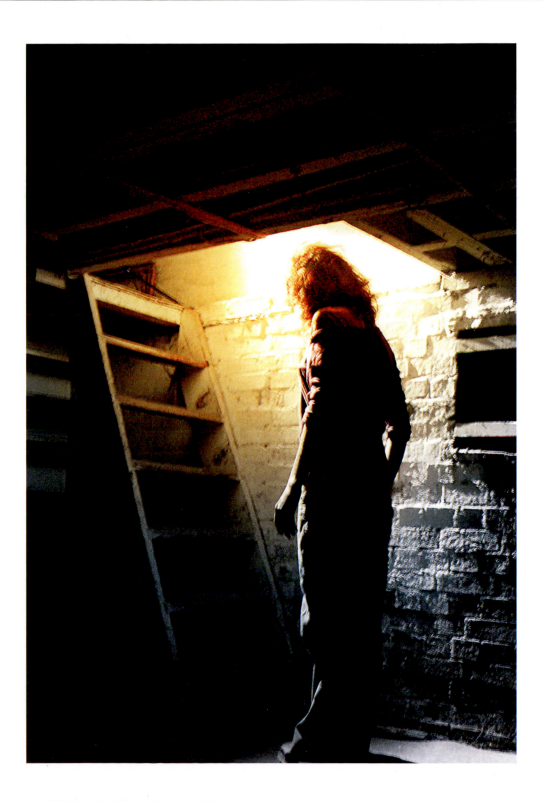

6-7
How to get the most out of this book

8-9
Introduction

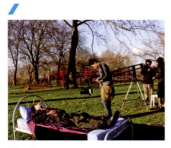

10-11
THE PRODUCER

12-15
The role

16-17
Different types of producer

18-33
The production process

34-35
The production team

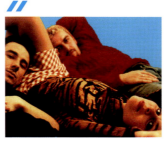

36-37
THE BASICS

38-39
Producer greats: Lois Weber

40-43
Copyright

44-47
Legal, ethical and practical issues

48-49
Health and safety

50-51
Shooting formats

52-61
Budget

62-65
Exhibition and distribution

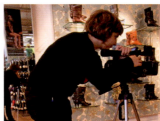

66-67
PRODUCING DOCUMENTARY

68-69
Producer greats: Susan Frömke

70-71
The team

72-73
Documentary styles

74-77
Development

78-79
Proposal and treatment

80-83
Budget

84-85
Pre-production

86-91
Production

92-93
Post-production

94-95
Case study: The producer/director

96–97
PRODUCING DRAMA

98–99
Producer greats: Matthew Weiner

100–105
The team

106–111
Development

112–121
Pre-production

122–123
Production/principal photography

124–125
Post-production

126–127
Case study: The creative producer

128–129
PRODUCING MAGAZINE SHOWS

130–131
Producer greats: Various

132–133
Types of TV format programmes

134–135
What is a magazine show?

136–137
The team

138–139
The production schedule

140–141
Production

142–143
Post-production

144–149
An example weekly magazine programme

150–151
Case study: The executive producer

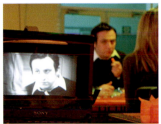

152–153
LEARNING CURVES

154–155
Producer greats: Andrew Eaton

156–159
Oliver Goodrum – Breathing In

160–163
Joao Tristao – Ambulance Blogger

164–167
Daniel and Jesse Quinones – Cage Fighter

168–171
Daniel and Jesse Quinones – Cold Calling

172–173
Conclusion

174–175
Glossary

176
Acknowledgements and credits

This book is intended to provide a starting point for inexperienced producers embarking on their first productions. Initial chapters explore the role and responsibilities of the producer, while later chapters look at documentary, drama and magazine programme production, focusing on what is needed to get the job done.

Headings
Help the reader to quickly locate a topic of interest.

Within the television industry, a single producer may be employed to take sole responsibility for a production. Alternatively, several types of producer may take responsibility for different areas of production, each with a specific role and with distinct responsibilities.

As many student or first-time productions have little or no funding, they will only be able to afford one producer. Also, these types of projects generally tend to be smaller in scale and therefore do not need the extensive teams often required in professional or major television productions.

PROGRAMME PRODUCER/ SERIES PRODUCER

Has overall business (budget, contracts), creative (script editing) and quality management responsibility for the programme. Controls the budget and hires the key creative members, such as the director, art director and editor of the production team.

EDIT PRODUCER

Usually employed on series or game show/reality TV formats. They oversee the editing stage of the project. They need to have strong storytelling and scriptwriting skills and be able to weave several parallel storylines into one programme.

DEVELOPMENT PRODUCER

Generates and develops ideas into scripts, proposals and programme formats. These projects are then pitched to TV companies and other sources of finance.

EXECUTIVE PRODUCER

Tends to oversee several projects in different stages of production, often at the same time. They liaise closely with the programme producer (as well as the broadcaster or commissioning body). They are involved in all aspects of the business and management of the production.

ASSISTANT PRODUCER

Works closely with the producer both editorially and creatively. The assistant producer can often play a key role, conducting much of the hands-on shooting, scripting and editing of programme content.

LINE PRODUCER

Can usually be found in film and TV dramas. They are hired at the end of development for the production period and into post-production. They help cost and manage the budget below the line and are responsible for hiring the crew.

STUDIO PRODUCER

Works within a television studio with presenters and has gallery/live transmission (TX) experience. Their job is to oversee the content of the programme, ensuring that the overarching concept, tone and style of the programme is being delivered.

Running glossary

> **Below the line** all the costs to technically make the film. Usually paid on a weekly or daily basis
> **Gallery** production control room within a television studio

Live transmission (TX) a programme broadcast to the audience as the event happens. Eg football matches, royal events etc
Script the written plan and dialogue for a film or programme

Running glossary

> **Proposal** a brief document that includes a description of the project, its intended audience and why it should be made
> **Programme format** a packaged programme idea such as 'Big Brother'.
> **Pitch** a short description of a programme idea

Broadcaster an organisation that distributes programme content to a public audience. Eg BBC, Sky, NBC, Fox and Channel 4
Commissioning body an organisation that offers finance and support to programme makers

The producer

The role > Different types of producer > The production process

Running glossary
Provides the definitions of key terms highlighted within the main text.

Box outs
Contain further information on the various roles within the production process.

Subheadings
Elaborate on the principles discussed in the main headings.

Images
A range of photographs, film stills, illustrations and forms that help to support the text.

Captions
Discuss the relevant image, helping to place it in context for the reader.

Professional tips
Provide essential guidance for the practising producer.

Starting points/tips
Provide useful tips and suggestions in order to help the aspiring producer to succeed.

Case studies
Feature practising producers and their working methods in order to help put their roles into context.

Navigation
Provided to help the reader find his or her way around the book.

Quotes
Have been highlighted within the text to emphasise insightful comments for the reader.

So you're interested in becoming a producer. You want to make films or work in the industry. Or you're simply new to this world and need to know more about production.

This book sets out to provide a broad and easy-to-understand introduction to digital film-making and TV production. It is targeted at not only the inexperienced film-maker looking for useful information, but also the reader with a general interest in the subject.

Never in the history of TV production have there been so many opportunities to make one's mark. Forever in a state of continual change, the media industry is increasingly caught up in a desperate search for new programme ideas, formats and audiences. Those working in the industry must incessantly change and adapt just to survive in such a highly competitive market place. On the plus side, this relentless development and expansion has engendered new opportunities. New digital technology is enabling student and independent film-makers to discover cheap and accessible ways to produce and distribute. It is with this fast-moving and rapidly changing environment that film-makers must engage.

This book will aim to provide the basic knowledge needed to produce drama, documentary and magazine programmes. It will explore the realities and challenges of the production process and examine the role of the producer. It will identify and break down aspects of the differing types of production. They will be clearly described and divided into designated areas, including basic budgeting, copyright, questions of legality and ethics as well as multi-platform distribution.

The book will explore the different types of producer that can be found in the industry, outlining their particular areas of responsibility and expertise. It will present case studies, which outline the producer's duties and responsibilities.

As well as providing essential information about current industry practices, the book will also consider the production process for student film-makers. A separate chapter is dedicated to students, who discuss the making of their films, highlighting the pitfalls they encountered and providing essential production tips.

Having the opportunity to make films and to experiment away from commercial pressures and the uncertainty of the freelance job market can be a liberating as well as a daunting experience. Gaining a rudimentary grasp of production basics can instil and help develop the confidence necessary to deal with the many challenges faced by the novice film-maker.

The producer

An introduction to the role of the producer and the structure of the production team. The producer's job is often the hardest to understand, so this chapter sets out to clarify the types of producer found in the industry, the skills they need, what they do and why.

The basics

Understanding the basic legal, financial and ethical principles involved in production are vital to the emerging producer. Being aware of these key issues will help you to plan and keep control of a production from start to finish.

Producing documentary

In a world where documentary film-making is flourishing, the producer brings real lives, new perspectives and compelling stories to an audience. This chapter introduces the building blocks to get the fledgling producer up and running.

Producing drama

Putting the story on the screen is the world of the drama producer. The creative process alongside the financial and practical realities of the job are introduced and explored in this chapter.

Producing magazine shows

The TV industry is hungry for new programme formats and ways to package old ideas in a fresh and exciting way. This chapter looks at the basics involved in producing a packaged show, demonstrating the ground rules and approaches.

Learning curves

This book should give the aspiring producer confidence and enough information to go ahead and make a film. In this final chapter, emerging film-makers discuss the highs and lows of production, giving helpful advice and real experiences for the inexperienced producer and film-maker to draw on.

How to get the most out of this book > Introduction

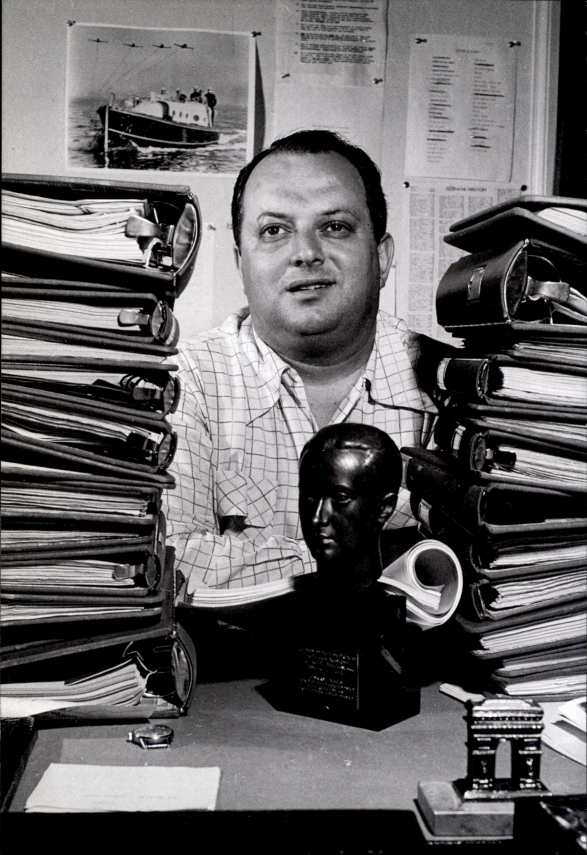

THE PRODUCER

The audience for news, sport and entertainment is global and growing. Billions of people across the world watch TV, access programmes on broadband or download content on to their mobile phones. Behind all these types of content there are small armies of people and all are led by producers.

Defining the producer's role may not be as straightforward as it might at first appear. It is perhaps easier to understand the roles of say, a director of photography (DoP), a scriptwriter or an editor. In a nutshell, the producer is a programme or film's key contributor – the driving force behind a project. The producer is likely to be the person who has nurtured or developed an idea before steering it to completion. The producer's role is challenging; a continual battle to remain faithful to the vision of the original idea against the constraints of time and money. The producer's responsibilities can be stressful and frustrating but, it should always be remembered, ultimately fulfilling when the vision finally makes it to the screen – hopefully intact.

This first chapter aims to introduce the role of the producer and explore the responsibilities it carries. It will outline the production process and the producer's role within it. It will also touch on the producer's relationship with the rest of the production team.

The bottom line is that being a producer is hard work, challenging and rarely glamorous.

The buck stops here!
The role of the producer is pivotal in any production. The responsibility and pressure can be stressful, but ultimately it is a fulfilling and rewarding job.

So what exactly does a producer do?

The producer may have developed and pitched an original idea to a broadcaster. He or she may have raised finance from a range of sources to fund the project. Alternatively, a production company may have hired a producer once a programme has been commissioned. Whatever the situation, the producer is the person responsible for holding a project together from start to finish, delivering the project on time and on budget. It is a tough and demanding role requiring an ability to make important decisions, often under challenging circumstances.

In low- or no-budget productions the producer will often be required to take sole responsibility for both the creative and administrative areas of the production. When confronted by the challenges of having little or no money at his or her disposal, the producer will be required to be creative and inventive to get the most out of available resources. The producer may need to personally organise and transport equipment, cast actors, recce locations as well as make sandwiches and cups of tea for cast and crew members on the shoot. This can be exhausting and stressful. Where possible the producer should try to delegate responsibility in order to prevent burning out and making mistakes.

It should be noted that in the world of bigger-budget productions the producer will work closely with a production manager on a daily basis. Essentially, the production manager will not become involved in any creative or editorial decision making, but will liaise closely with the producer to deliver a project on time and within an agreed budget. It is the producer who will have meetings with the writer, the commissioning editor or the executive producer. In short the role of the production manager is to oversee the smooth running of all practical aspects of production.

A producer needs to be highly organised, motivated and knowledgeable about all areas of production. As well as taking responsibility for all editorial decisions, such as final script approval and hiring key production team members including the director and the production manager, the producer needs to be confident and grounded with a good knowledge of the financial, legal and technical aspects of production. He or she also needs to be able to manage a team and build trust, taking overall responsibility for the project and any problems that may arise. In the end the buck stops with the producer.

For useful websites providing information on training, visit: www.npa.org.uk, www.globalfilmingschool.com, www.film-connection.com and www.ec.europa.eu/information_society/media/index_en.htm.

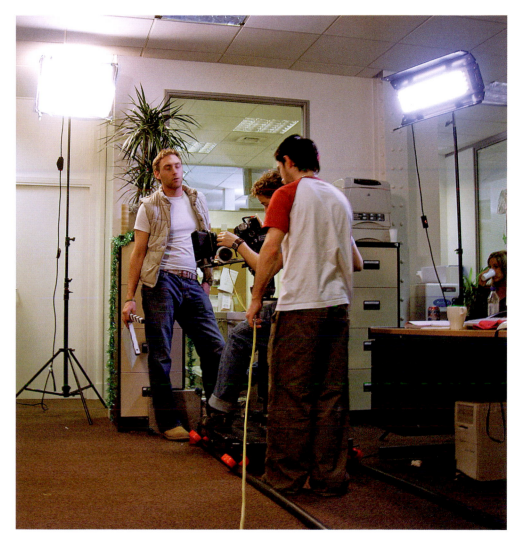

Managing a team
The producer is responsible for key members of the production team. This requires not only good organisational skills, but tact and diplomacy.

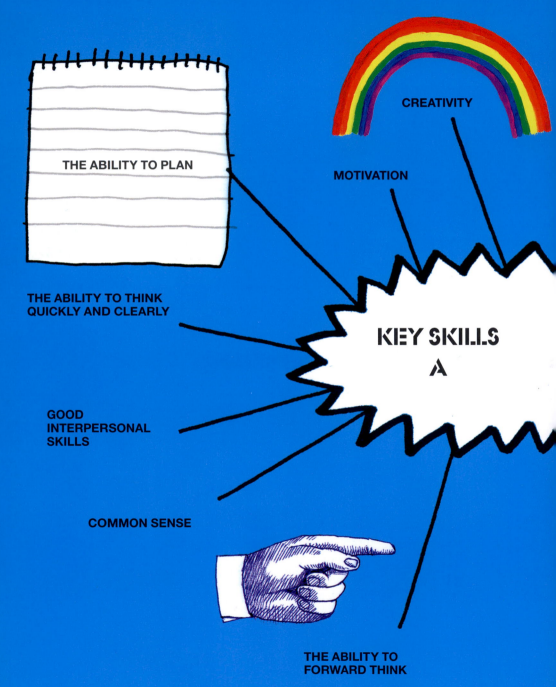

THE ABILITY TO PLAN

CREATIVITY

MOTIVATION

THE ABILITY TO THINK
QUICKLY AND CLEARLY

KEY SKILLS
A

GOOD
INTERPERSONAL
SKILLS

COMMON SENSE

THE ABILITY TO
FORWARD THINK

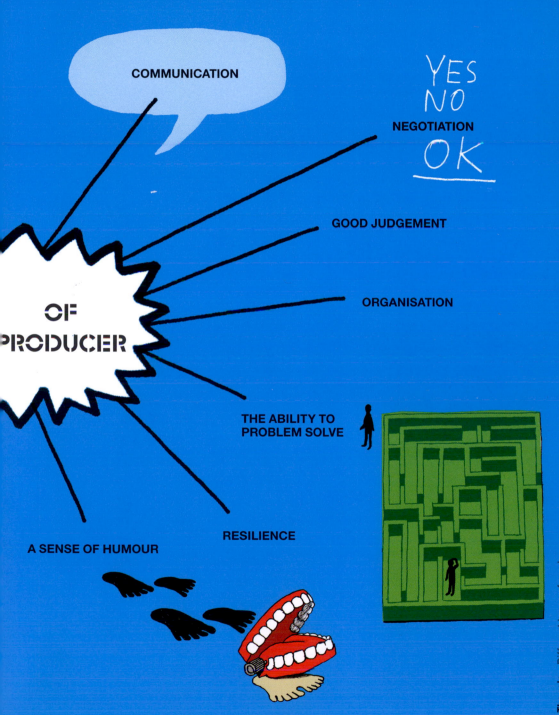

COMMUNICATION

YES
NO
NEGOTIATION
OK

GOOD JUDGEMENT

ORGANISATION

OF
PRODUCER

THE ABILITY TO
PROBLEM SOLVE

RESILIENCE

A SENSE OF HUMOUR

Within the television industry, a single producer may be employed to take sole responsibility for a production. Alternatively, several types of producer may take responsibility for different areas of production, each with a specific role and with distinct responsibilities.

As many student or first-time productions have little or no funding, they will only be able to afford one producer. Also, these types of projects generally tend to be smaller in scale and therefore do not need the extensive teams often required in professional or major television productions.

PROGRAMME PRODUCER/
SERIES PRODUCER

Has overall business (budget, contracts), creative (script editing) and quality management responsibility for the programme. Controls the budget and hires the key creative members, such as the director, art director and editor of the production team.

ASSISTANT PRODUCER

Works closely with the producer both editorially and creatively. The assistant producer can often play a key role, conducting much of the hands-on shooting, scripting and editing of programme content.

LINE PRODUCER

Can usually be found in film and TV dramas. They are hired at the end of development for the production period and into post-production. They help cost and manage the budget below the line and are responsible for hiring the crew.

Running glossary

> **Below the line** all the costs to technically make the film. Usually paid on a weekly or daily basis
Gallery production control room within a television studio

Live transmission (TX) a programme broadcast to the audience as the event happens. Eg football matches, state events etc
Script the written plan and dialogue for a film or programme

The producer

EDIT PRODUCER

Usually employed on series or game show/reality TV formats. They oversee the editing stage of the project. They need to have strong storytelling and scriptwriting skills and be able to weave several parallel storylines into one programme.

STUDIO PRODUCER

Works within a television studio with presenters and has <u>gallery/live transmission (TX)</u> experience. Their job is to oversee the content of the programme, ensuring that the overarching concept, tone and style of the programme is being delivered.

DEVELOPMENT PRODUCER

Generates and develops ideas into <u>scripts</u>, <u>proposals</u> and <u>programme formats</u>. These projects are then <u>pitched</u> to TV companies and other sources of finance.

EXECUTIVE PRODUCER

Tends to oversee several projects in different stages of production, often at the same time. They liaise closely with the programme producer (as well as the <u>broadcaster</u> or <u>commissioning body</u>). They are involved in all aspects of the business and management of the production.

Running glossary

> **Proposal** a brief document that includes a description of the project, its intended audience and why it should be made
> **Programme format** a packaged programme idea such as 'Big Brother'.
> **Pitch** a short description of a programme idea

Broadcaster an organisation that distributes programme content to a public audience. Eg BBC, Sky, NBC, Fox and Channel 4
Commissioning body an organisation that offers finance and support to programme makers

Before you can understand the specific responsibilities of being a producer, you will need to have an overview of how a project gets on to the screen. This section will outline each stage and what is specifically required of the producer.

Grasping and understanding the problems, pitfalls and needs of each stage of production can only really be acquired through the experience of working on real projects. A small-scale student or first film can really help a fledgling producer to gain experience without having the responsibility of managing a significant budget or dealing with a large production team. In addition to this, having a basic conceptual understanding of all the stages of production can really help the inexperienced producer to grasp the process and what is expected from them at each stage of production.

From the student film to the most complex broadcast productions, they all tend to follow these key stages:

EXHIBITION

DISTRIBUTION

POST-PRODUCTION

IDEA

KEY STAGES OF
A PRODUCTION

DEVELOPMENT

PRE-PRODUCTION

PRODUCTION

Different types of producer > The production process > The production team

/ Development

This is when the idea is moved forward creatively. The proposal or script is drafted, an outline budget (the provisional costs) and production schedule (an estimate of how long it is going to take to make) are drawn up. (See Chapter Two: The Basics for discussion on budgeting and scheduling). At this stage the producer may approach key production members, actors and writers in order to attach them to the project. This may make the project more attractive as an investment to prospective funders. Being able to confirm that you have exclusive access, or that a well-known actor or an experienced drama scriptwriter is attached to the project, immediately raises the profile of the production, attracts finance and increases the likelihood of a larger audience.

It should be remembered that at this point there are no guarantees the project will be made. This stage of the production cycle can last for many years, which can be both costly and frustrating – particularly as the project may never go ahead.

Funding is always a fundamental consideration when it comes to working on a film or TV programme. A crucial aspect of the producer's role is to know whom to approach. Possible sources of funding can come from a range of sources, such as broadcasters like the BBC, ABC and CBS, awards from such organisations as the UK Film Council, sponsorship or pre-sales agreements.

Further funding details can be found at: www.britfilms.com and www.ec.europa.eu/information_society/media.

Professional tips

All projects begin with an idea. At this stage there will need to be a range of questions asked about the viability of the subject. The following are the types of questions that a producer will need to ask:

- Are there similar projects already in production?
- What is unique about the project?
- What are its strengths and weaknesses?
- Is it filmable?
- Is there exclusive access to the story or characters?
- Is there an audience or market for the film?
- Who is the audience?
- Where is the money coming from to make it?
- How much will it cost?
- Has wider opinion been canvassed about the idea?
- Is the story/concept in the public domain?
- Are there copyright issues?
- If there are copyright issues, who owns what?
- Who owns the script/idea and how long should the option be for?
- Who should be hired to write the script?

When approaching possible funders or broadcasters, the producer will need to have developed the proposal or script and be ready to make a brilliant pitch. A written and verbal pitch needs to clearly describe the project in a few concise and engaging sentences. The producer must excite prospective funders, often in a short period of time and in the context of a highly aggressive and competitive market place. The most important thing to remember is that the project has to be distinctive; it needs to stand out.

Even if a project is a no-budget, a low-budget or a student production, the film-maker or producer should be in no doubt that they are working within financial constraints. However, in most cases a lack of money can be offset with the investment of long hours, commitment and negotiating skills. A talented producer who has little or no budget should be able to charm or haggle in order to get the best deals on equipment or access to an edit suite in unsociable hours. The producer should also be capable of organising the production schedule in the face of conflicting availability and commitments of crew and cast members.

The idea
Coming up with the idea is just the beginning of the film-making process for the producer.

Starting point/tips

Funding can come from a range of sources, such as:
- Broadcasters
- Distributors or film studios
- Private investors
- Sponsorship
- Grants
- Loans
- Pre-sales of a film to certain markets
- Cast and crew deferments
- Friends and family
- Your own money

Different types of producer > **The production process** > The production team

/ Pre-production

This stage begins when the project has been given the go ahead (green light) and any relevant contracts with the main actors, the director and the writer are negotiated and signed. Running any type of production is complex and all projects need a base from which to work, so a production office will need to be established. This could be in a fully serviced rented office space, or just a desk sublet by a production company or even – in student productions – a friend's front room where a mobile phone is the only piece of equipment. The production office will keep running right up to the end of the editing and delivery of the project to allow the clearing up of loose ends and paperwork.

It is also at this stage that the budget is developed in greater detail. Once a project is officially up and running, actual deals and specific quotes for equipment hire, catering and editing time can be negotiated to get the best prices.

Another issue relating to the budget that may be raised by the producer concerns the director's creative vision. For example, the director may insist that the filming takes place in a location that is expensive to hire, or in a location that is remote, making access difficult. Conflict may arise at this stage over whether an idea is achievable within the constraints of available time and money.

Location shooting
Planning and preparation ensure that the shoot proceeds smoothly.

Professional tips

A producer's responsibilities during pre-production include:

- Overseeing scripts and storyboards
- Negotiating casting (agreeing rights and fees)
- Booking crew and equipment
- Researching locations and agreeing access
- Researching possible use of music and clearances
- Arranging production insurance
- Preparing and carrying out risk assessment
- Drawing up production schedules
- Establishing a delivery date (changes made later in the production can be very expensive)

Shooting on location
Although a producer will not be directly involved in making decisions about the creative direction of a shoot, it is their responsibility to ensure that the creative vision can be achieved within the limits of time and money.

Production

Production is when the project is filmed <u>on-set</u> or <u>on location</u>. Depending on the type of project and the size of the budget, production may take days, weeks, months or even years. The producer will not generally be directly involved in the creative aspects of the production. It is the director who will be dealing closely with the director of photography (DoP), actors and participants. More importantly perhaps, the producer will be liaising closely with the director to ensure that their creative vision can be fulfilled within the limits of time and money. The producer's role is to organise, manage and troubleshoot throughout the life of the production. The key skills a producer needs at this stage of production are the ability to solve problems and to think on their feet. However well planned and organised a production, a producer should expect things to go wrong.

Running glossary

> **On-set** scenes can be shot in studios or stages, which are fitted out with rooms, walls or backdrops by the art department
> **On location** real interiors or exteriors used for filming

Edit suite
The edit suite is where the film
footage is edited into the finished
film or programme.

Professional tips

A producer's responsibilities during
post-production include:
- Finding an editor – where possible
 the producer needs to find an
 editor who is compatible with
 the director and the project
- Confirming edit and sound
 post-production facilities
- Clearing outstanding music
 and archive licences

- Dealing with, preparing, and distributing
 publicity materials
- Delivering the completed programme and
 relevant paperwork to the client
- Ensuring outstanding bills are paid and a
 budget summary of all costs is completed

Post-production

Post-production is the final stage of the production process. This is where the filmed footage, known as rushes, are edited into the finished film or programme. The producer must ensure that the edit keeps to the production schedule and budget. They always have to be one step ahead to resolve any unforeseen problems, such as unexpected costs that may arise from additional filming (reshoots) or the use of too much stock; both of which can eat into the post-production budget. The student or inexperienced beginner will often exceed the planned edit schedule for a variety of reasons. He or she may be slower to make decisions, be less confident with the technology or just lack the ability to take an objective overview about the emerging film.

The director, meanwhile, will work closely with the editor to shape the final product. Often the director will want to be left to work with the editor and will not want the producer to be in the edit until the first cut is finished. An experienced producer will see this as a positive situation as this will provide an opportunity to view the director's first cut objectively with a clear head and fresh eyes.

Editing
The editor needs to keep a keen eye on the editing schedule to ensure that everything goes to plan.

/ Linear and non-linear editing

Traditionally, nearly all television video editing took place in a tape suite. The feature was prepared by editing shots sequentially, one after another, on to a master tape, called 'linear editing'. The disadvantage was that in order to change or move a shot, the editor would need to return to the edit point where the change was made and re-edit the sequence from that point. This tended to be time-consuming and expensive.

The advent of non-linear editing products such as Avid and Final Cut Pro enabled editors to move shots, change sequences and alter durations at will and in minutes. The only disadvantage of this system is the amount of time it takes to digitise or capture material for the project.

For more information on Avid and Final Cut Pro, visit: www.avid.com and www.apple.com/finalcutpro.

The key stages in digital post-production are:

- Digitising or capturing the shot footage or rushes into a digital format and organising the footage into bins
- Editing: the stage when the footage is cut together
- Re-recording or dubbing dialogue
- Adding voice-overs
- Adding audio effects and music
- Sound dubbing: the stage where all the soundtracks come together to complement the final picture
- Grading or colour correction
- Laying back sound to video where the final mix is added to the final picture on a new master tape. (Versioning needs to be taken into account during this stage as, if a programme is being shot abroad, it will need to be transferred to the required format or television standard. There are many different video/digital formats throughout the world)
- Dubbing delivery masters
- Dubbing backup masters
- Dubbing viewing/publicity copies on to DVD or other formats.

Running glossary

> **Rushes** shooting footage ready for editing
> **Bins** non-linear editing term for the location of the digitised rushes

Editing software
Software packages, such as Avid and Final Cut Pro, are invaluable to the editor as they enable them to move shots, change sequences and alter durations with a click of a button.

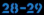

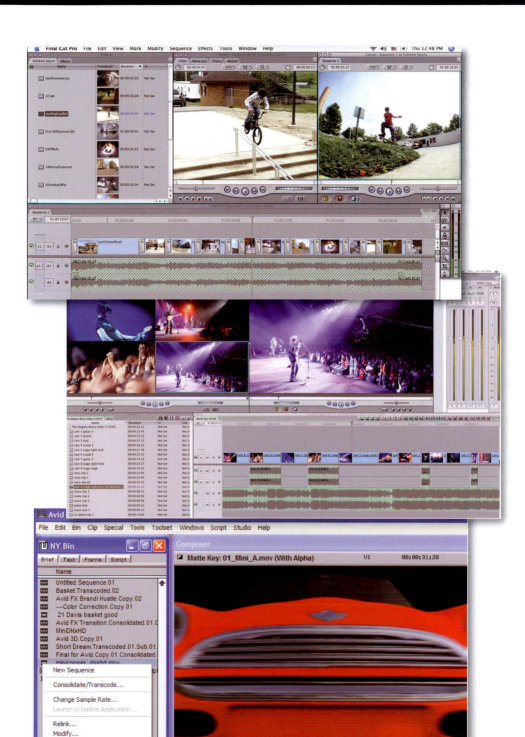

Sound post-production (sound dub)

Once the pictures have been edited there is yet another crucial stage of post-production to be negotiated before the product is truly finished. This is to create a final soundtrack. Before track laying the soundtrack will usually contain only the dialogue and sound recorded on-set or on location. More often than not the recording levels will be uneven and a voice-over may be needed. Music and sound effects may also need to be added. This stage is called the 'sound dub' and takes place when all the separate soundtracks for effects, music and voice-over are laid down and finally mixed to create the final soundtrack for the finished film.

All television and film productions are a combination of both video and audio; put simply, a combination of sound and pictures. One without the other will compromise and diminish the quality of production. The importance of audio track laying, mixing of the sound and final lay back on to the master tape should not be underestimated.

Sound and sound design are very creative aspects of film-making and the acquisition of good quality sync sound during filming is a vital aspect of the process. Unfortunately, these areas are often overlooked by student film-makers, either because of a lack of experience or as a result of the pressures of filming. This can lead to poor sound recording and a lack of attention to detail in post-production. This oversight can have a dramatic impact on the quality of the final film. Setting aside enough time to create a sound design is extremely important and should always be factored in.

Professional tips

There are various different TV standards across the world. All TV pictures are made up of a series of horizontal lines. As a rule of thumb the more lines there are, the better quality the image on the screen. The main TV standards are as follows:

· **PAL** (Phase Alternate Line) is used in the UK and Western Europe. The TV image is made up of 625 horizontal lines

· **NTSC** (National Television System Committee) is used in the USA, Japan and Canada. The picture is made up of 525 lines

· **SECAM** (Séquentiél Couleur à Mémoire) is used in France, Russia, Eastern Europe, Asia and Africa. The picture has 625 lines

· **HD** (High Definition) is the next generation of TV standards. The TV image is made up of 720 or 1,080 lines

/ Delivery

Once the project has been edited and master tapes produced, the producer will be required to deliver or hand over the programme to the broadcaster, production company or client. It should be remembered that a broadcaster can reject a programme if the finished content does not meet the technical requirements outlined in its technical specification.

The client or distributor will outline exactly what they need from the programme with the producer. A master copy of the programme is the first item on the list. It is always good practice to make two copies, the master and a second or safety copy as a backup. This will include a clean M and E audio track or tracks if stereo. The M and E track is separate to the voice-over track and should be made available on the masters. Providing an M and E track means that the project can be made available for international distribution. With an M and E track any foreign language broadcaster may overdub their language using the clean audio M and E track to make a final new mix.

As well as a programme master, a transcript of the programme will be required. The transcript will be an accurate script of the programme including all dialogue and interviews. The transcript can also be used by the legal department to check any potential legal issues and is useful for the preparation of subtitles. Other legal paperwork required will be copies of all contracts, permissions, and footage and music clearances. The producer will also need to provide a final cost report, which will include the final budget in detail and an analysis of the final and true cost of the programme.

In order to maximise the potential audience for the project, publicity material should be provided. This could include publicity stills, images of the actors or participants and short biographies of key cast and crew. The producer will always be aware that programme delivery is not considered complete until the broadcaster or client accepts the finished show.

Different types of producer > **The production process** > The production team

Running glossary

> **M and E** music and effects track, separate to the dialogue
> **Transcript** the finished programme including dialogue and interviews

Distribution
Distribution is a vital part of the film-making process. It is essential that the film is seen by as many people as possible.

Delivery materials checklist:
- · Master tape with M and E track
- · Safety copy
- · Transcript or script
- · Contracts
- · Location contracts
- · Music clearances
- · Footage clearances
- · Publicity stills
- · Short cast and crew biographies

Distribution and exhibition

What's the point of all the hard work, the sleepless nights, and the stress if the programme is not seen? It is essential to remember the film should be seen by as many people as possible. Some projects will have a predetermined market, such as a broadcaster. Others will have been produced as part of college work or as a calling card to the industry to advance the career of a budding producer or director. Whatever the background to the project they all need some form of distribution and exhibition.

Researching the distribution and exhibition possibilities for a project should take place early in development and pre-production. Starting early in the production and selling the project before shooting enables the producer to target appropriate markets. Money should normally be set aside in the budget to cover the costs of this stage of production. This will help pay for making extra copies, film festival entry fees and press kits.

Clearing up

The final responsibility of the producer will be to tie-up any loose ends and close down the production office. They will need to check all bills have been paid, send out publicity copies and deal with any queries.

Running glossary

> **Distribution** markets for selling programmes
> **Exhibition** places to screen in front of an audience
> **Press kit** publicity package, which includes relevant information for a film

Both the TV and film industries have traditionally operated on hierarchical lines. All members of the production team have tended to have very closely defined roles and responsibilities. However, technology is moving fast and the arrival of lighter cameras and delivery platforms are encouraging multi-skilling and self-shooting. Today one person alone can often direct, produce, shoot and edit a project.

During the shoot, members of the production team will be working closely with the crew. Depending on the type of production the crew can vary in size from just a single camera person and sound recordist to a crew the size of a small army.

Key roles that may be found in the production team include:

DIRECTOR

Responsible for the creative and technical realisation of the project.

SCRIPT EDITOR

Oversees and manages the progress of the scripts.

CASTING DIRECTOR

Must find suitable actors for the project and work closely with the director and producer in pre-production.

PRODUCTION MANAGER

Organises and co-ordinates the production needs of the project. They will hire the crew and deal with employment contracts, organise equipment hire, insurances, accommodation, travel, catering and deal with day-to-day production problems. They will also check and keep control of the budget.

LOCATION MANAGER

Finds locations and organises access as necessary.

ASSISTANT PRODUCER

Responsible for much of the researching, shooting, scripting and editing, especially in TV magazine programme production.

RESEARCHER

Involved in the bulk of the background research of a project, identifying key participants, facts and locations.

PA (PERSONAL ASSISTANT)

Usually assists the producer. They are responsible for paperwork, copying scripts, filing and other office duties.

RUNNER

Essentially a person with energy, enthusiasm and the ability to fit easily into the team. The runner is expected to engage in all aspects of supporting and assisting the production team. Running is traditionally the route into the industry.

POST-PRODUCTION TEAM

Made up of the editor and sound editor. They are primarily involved in the editing of pictures and sound.

Starting point/tips

A basic crew will include the following members:
- Director of photography: (also known as a DoP or camera person/lighting camera person)
- Camera assistant: assists the shoot by doing activities such as preparing and labelling tapes
- Sound recordist: responsible for the recording of all sound

The production process > The production team

THE BASICS

Now that you have an insight into the role of the producer, the next stage is to acquire some of the essential knowledge and expertise needed to do the job. As outlined in Chapter One, the producer's role is complex and involves dealing with many issues and situations. A seasoned producer, while keeping an eye on the day-to-day running of the project, will have the ability to handle a range of business-related issues and confidently negotiate with a range of individuals and organisations.

So the next stage of familiarising yourself with the job of the producer is to grasp some of the basic professional skills and to be aware of some of the legal and ethical guidelines.

This chapter will deal with the principles of copyright, introduce basic legal and ethical issues and take into account approaches to health and safety. It will also touch on core technical issues and new technology. The chapter will go on to establish the principles of budgeting and scheduling as well as to consider aspects of distribution, publicity and exhibition.

Organisation and planning
A producer has to manage a lot of different processes and people. In order to do this they must be organised, have exceptional planning abilities and remain calm under pressure.

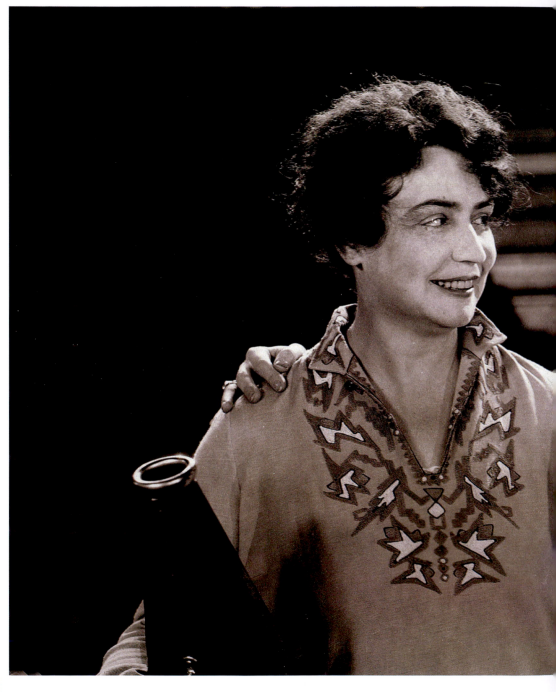

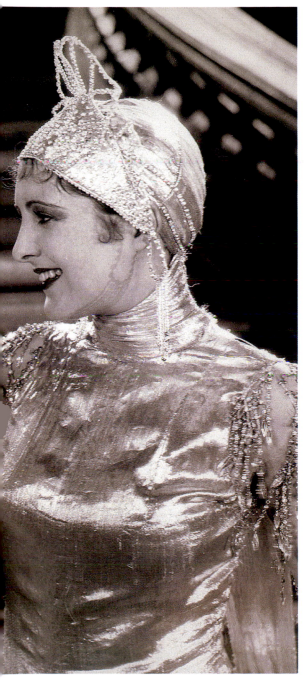

/ The Marriage Clause, 1926

Synopsis

In *The Marriage Clause*, a Broadway actress, Sylvia Jordan (Billie Dove), becomes a star due to the guidance of her director, Barry Townsend (Francis X Bushman). The two fall in love, but are prevented from marrying due to a clause written into her contract by her producer (Warner Oland), which prohibits her from marrying during its three-year duration. Feeling betrayed, Townsend retires from show business, whereupon Sylvia falls into decline, culminating in her collapse on-stage during the opening night of her biggest show. Eventually, Townsend and Sylvia are reunited and the marriage clause nullified.

Lois Weber

Lois Weber was a silent-film actor, director, writer and producer and her work was regarded as being equal to, if not better than, her male counterparts.

Weber made hundreds of films that ranged in subject matter from controversial topics such as capital punishment, religion, and politics; to more intimate examinations of marriage and relationships.

A favourite song, a clip from a feature film or an iconic photograph…

When a film-maker makes the creative decision to include material from other sources such as music, photographs or film footage in their film, the issue of copyright and potential copyright infringement is raised. There can be serious legal and financial implications for a producer if they use any material in the project that belongs to someone else without first negotiating a licence or permission. If a programme-maker decides to use certain footage or music they will need to receive permission or pay for the right to use it in their film.

Copyright laws protect the writer, musician, artist and film-maker from others using and exploiting their work without permission. A producer should be thoroughly grounded in copyright law and methods of clearing copyright. Conversely, the law will also protect your work from being exploited by others.

As all countries have their own copyright laws and limitations, a producer will need to familiarise themselves with these and make sure they comply with them.

There are international treaties such as the Berne Convention, which have harmonised the complex variety of legislation. Creative Commons is a new form of licensing aimed predominately at work showcased on the Internet. It allows work to be shared, copied or distributed under specific conditions decided by the creator of the work. It is something to be aware of and may be relevant to some types of production. Further details can be found at: www.creativecommons.org.

More information on copyright can be found at: www.ipo.gov.uk, www.wipo.org and www.copyright.gov.

It should be noted that an idea in itself cannot be copyrighted, but the way the idea is expressed can, as in a script with dialogue and specific characters or a TV programme format.

Running glossary

> **Licence/permission** a document that outlines the terms/fee for using music or footage in a film
> **Berne Convention** international agreement regarding copyright

Starting point/tips

● When shooting on location any music playing on radios or sound systems should be turned off where possible. This makes editing less problematic and avoids potential copyright issues.

Copyright

There are various copyright issues to consider as a producer, and each country has its own set of laws and limitations. It essential for the producer to be familiar with these laws and to ensure compliance with them.

/ Copyright periods

Copyright covers a wide range of creative works including books, films, music, broadcasts and sound recordings, for example CDs. Copyright protection normally covers the life of the creator (for example, writer, director or composer) plus a clearly defined period of time after their death. If it is not possible to trace the creator, copyright usually expires a period of time after the work was made or made available.

As this period of time can vary from country to country and can change with amendments to legislation, the producer will need to check closely the relevant laws at the time of production to avoid breaching copyright.

More information on copyright can be found at: www.wipo.org and www.copyright.gov.

Music clearances

If commercial music is being included in a production, the producer will need to identify who owns the copyright and clear it ahead of delivery and screening. Permission usually involves paying a fee for the music used and having a licence issued. The amount of fee paid depends on a range of factors including how much of the track is used in the film. Even if the track is used for only a few seconds it still has to be cleared and paid for.

A producer will have to clear all music in a film, including background music, unless it can be proved that it was incidental or unintentionally included during filming. For example, music played over a public address (PA) system when filming a documentary at a public event, where the sound cannot be controlled.

The type of music clearances to be negotiated normally include the publishing rights and recording rights. The publishing rights belong to the owners of the lyrics and the composition. The recording rights belong to the performers of the music. This information can be found on the packaging or by contacting industry organisations.

During post-production the producer will need to make sure a music cue sheet is completed. This document clearly describes all of the music tracks used, their duration in the film and who owns them. The music cue sheet will be included in the delivery paperwork required by broadcasters.

For low-budget projects the best way to avoid the high cost of music clearance is to commission specially composed music. The producer will still have to make sure that the composer and musicians have given permission for the music and their performance to be included in the film, so contracts will have to be signed.

Another option is to buy the use of pre-cleared library music. For a small one-off fee, library music can be obtained from websites such as Media Music Now (www.mediamusicnow.co.uk).

/ Public domain

In some cases material may have no recognisable owner and is described as being in the public domain. This material may be used without a licence or permission. Material will be in the public domain if the copyright has expired or the owner has deliberately put it into the public domain (a notice will be placed with the material indicating this). Certain government or public body material is free of copyright, such as footage from NASA's space missions (see www.nasa.gov).

The producer must be absolutely certain and thoroughly research that this is the case before including it in any production.

/ Fair dealing

Fair dealing (also known in the USA as 'fair use') allows limited and tightly controlled use of copyrighted material in certain circumstances, such as news reporting, criticism, review or private study. There are restrictions on the use of material, including the proportion of the material that can be used in relation to the length of the programme, that the source is sufficiently acknowledged, and that the work was previously made available to the public. In countries such as the UK, copyright law is complex and ultimately it is the producer's responsibility to always ensure copyright is not being infringed. If unsure, take legal advice.

Professional tips

// The laws of copyright cover a wide range of creative work including:
- · Literature: books, plays, screenplays and articles
- · Drama: dance or mime
- · Music
- · Art: sculpture, paintings, photographs and maps
- · Sound recordings
- · Film and broadcasts

Starting point/tips

● Always assume that someone, somewhere – be it an individual or organisation – owns the material you want to use within your programme. The golden rule is to research, research and research again!

Making programmes can involve dealing with difficult subject matters, vulnerable participants or delicate situations. There will be occasions where the producer is faced with having to make sensitive and considered decisions about what is being filmed and why. It is a complex and sophisticated part of film-making, and a very serious part of the responsibilities of being a producer.

Here are some of the basic pitfalls of which a producer needs to be aware when working on a project:

/ Privacy

A producer will have to make decisions about the type of filming undertaken and consider whether it is invading a person's privacy and dignity. If the filming is invading the privacy of an individual, consider whether this is in the public interest. An example would be an investigative report into fraud and corruption. Filming in certain sensitive locations, such as hospitals, schools, prisons and nursing homes, will require permission from the relevant people. Always stop filming if asked to do so, unless there is a strong editorial reason to carry on.

/ Defamation

These are false comments, accusations or statements, which could harm or affect the reputation of a living person or company. A person can sue for defamation if they believe that their reputation has been harmed.

Privacy and consent
It is the producer's responsibility to decide whether or not any filming undertaken in a public space is invading a person's privacy.

Working with children

Any filming with children (broadly defined as a person under the age of 18), paid or unpaid, is closely regulated and will require permission from several authorities. Apart from the parents or legal guardians, the local education authorities and school also have to be closely consulted. There are also regulations and restrictions on how long a child can be on-set. The producer will need to make provision for the education and well-being of the child during filming and organise an appropriate chaperone.

Consent

A producer must seek the consent of a contributor, preferably in writing or on camera. There will be some situations when certain individuals will not be in a position to give their informed consent. They may be vulnerable individuals, terminally ill or critically injured patients, or the recently bereaved. It is the producer who will normally have to decide whether to film people incapable of giving their permission and whether or not it is appropriate to continue filming.

Working with children
Any filming involving children must be approved by several authorities, as well as the parent or guardian, before shooting can take place.

Copyright > Legal, ethical and practical issues > Health and safety

/ Shooting on location

Filming anywhere outside of a studio or a set is called 'shooting on location'. In the first instance a producer can work with a location manger or location scout to find the right type of property or exterior location to meet the needs of a particular project. At all times the producer will need to have an eye on the budget as well as the shooting and delivery schedule.

There are ranges of creative and technical factors that need to be considered when choosing filming locations. At the very least the location needs to have access to a range of facilities such as electricity, water, toilets, parking and public transport.

The following lists some basic issues to consider for all types of location shooting:

Access

Any shooting on public or private property requires permission. This must be negotiated with the owners in advance. The producer will need to ensure that a location agreement or permit is signed, a copy of which needs to be kept with the rest of the production paperwork. Depending on the budget, location fees should be taken into consideration even if this represents only a token amount to cover, say, the use of electricity. A courtesy payment often helps.

Insurance

Public liability insurance is necessary when filming. This legally covers the production against any injury or accident to members of the public or damage to property as result of filming. Depending on the type of production, the producer will also have to consider insurance to cover employer's liability (compulsory in the UK – protects employees and the company), cast, props, assets and wardrobe, and errors and omissions (producer's indemnity). A college or university may cover a student film-maker; this will need to be confirmed in writing. For a list of specialist insurance brokers and further details, see: www.theknowledgeonline.com.

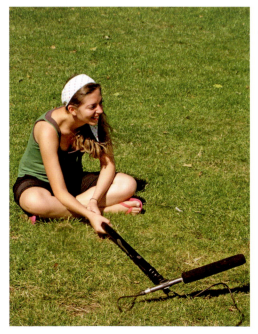

Sound
When a location is chosen, attention should be given to how it sounds. This is important not only for the acoustics, but to ascertain whether there is any extraneous noise to contend with.

Health and safety

The producer must ensure the safety of the cast, crew and members of the public at all times. A detailed risk assessment must be produced for each location and is often a requirement before filming permission is given. All crew should wear reflective vests when shooting after dark, at sporting events and when shooting on the public highway.

Police

Official police permission must be sought if any street filming involves firearms, nudity, replica uniforms or emergency service vehicles.

Sound

A location is primarily chosen for its visual look and size. Attention should also be given to how it sounds. A thorough recce of a location will indicate any problems with acoustics, such as creaky floors and extraneous sound, such as busy roads, flight paths, factories and schools. Having to stop and start filming because of sound interruption slows down the schedule and can cause problems in the edit.

Weather

Be ready for rain, wind and snow. Weather can have a dramatic impact on the best-laid plans of the production team when on location. Consulting a five-day weather forecast can flag up any potential problems, thus allowing a well-prepared production to fall back on alternative arrangements for the shooting days, such as shooting indoors.

Looking after the location

It goes without saying that any location must be respected and left in the condition in which it was found. Nurturing and maintaining a good professional reputation in the business is essential. You never know if and when you may need to use the location or deal with its owners again. Also, good practice enables other production teams to work there after you.

Many towns and cities have local authority film commissions or offices that can give comprehensive advice and support to all professional and novice film-makers.

Running glossary

> · **Public liability** insurance that covers the production company against claims for injury or damage to property
> · **Recce** pre-shoot visit to a location to assess its suitability for filming

One of the responsibilities of the producer is to ensure that the crew, cast and members of the public are not put at risk from filming and are safe at all times. Filming can be inherently hazardous due to the combination of camera equipment, lights, crew and cast working in a range of locations under pressure and to tight schedules. The producer should identify and minimise the hazard by asking the following questions:

- What are the risks?
- What is the likelihood of something going wrong?
- What is the severity of the risk?
- Who is at risk?
- What measures can be put in place to prevent an incident occurring?
- What regulations or legislation need to be considered?

Once these questions have been answered the producer must prepare a risk assessment form for each location. The form indicates the type of hazard that might be encountered, the severity of the risk, any measures put in place and the actions that might need to be taken. The forms are completed and signed by the producer before the shoot takes place. The producer should countersign the form if another member of the team has been delegated to complete it. All members of the crew need to be given a copy and made aware of any safety issues.

Some types of production are inherently more problematic than others. For example, working with stunts, children or animals will present more unpredictable and complex health and safety issues. For more information on health and safety, see: www.bbc.co.uk/dna/ filmnetwork/legalguidehealthandsafety.

Potential hazards
There are various potential hazards during filming, due to a combination of equipment, such as cameras and lights, and crew and cast, all working to tight schedules and deadlines. It is the producer's responsibility to ensure that any potential hazards are minimised.

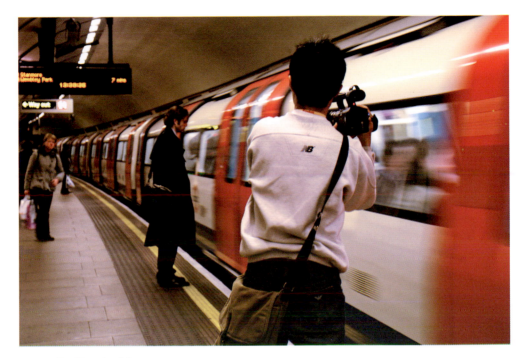

Health and safety
Before filming can begin, the producer must identify all potential risks and compile them in a risk assessment form.

Starting point/tips

- Plan ahead
- Keep all equipment secure, and do not leave it unattended
- There should be at least two crew members on a shoot, especially when using lights
- Do not put lights near anything flammable or anything sensitive to heat
- Ensure lights are weighed down and cables taped down
- Keep all electric cables away from water
- If shooting in a location where there are animals or pets, ensure they are kept safe and secure with adequate food, ventilation and water
- Make sure people know where you are going and that you can be easily contacted on location
- Any filming that involves the use of replica firearms or other weapons will need special permission from the police and local authorities
- Do not shoot anywhere without permission and do not break the law

A decision that will need to be made early in pre-production is whether to shoot on film or on a tape format. This decision will be made for both financial and aesthetic reasons. Film arguably looks better but is always more expensive. However, the formats are converging and it is now possible to transfer film to tape so that it may be edited digitally. At the moment it is almost always more economical to shoot on to tape than film.

/ Tape formats

Currently there are several tape formats available to shoot on, each with varying costs and image quality. The most common are:

- VHS: Poor quality, cheap, used mainly for duplication – in decline
- Mini DV: Smallest of the digital video formats
- Betacam SP: Once an industry favourite
- Digibeta: Currently the industry favourite
- HDV: A higher quality format
- HD: Exceptional quality and detail, making it a viable alternative to film.

Many of these formats will eventually become obsolete because of significant developments in new technology and the shift to tapeless cameras. These cameras allow footage to be recorded directly on to memory cards, which can then be directly downloaded, edited and played out without using tape at any stage.

/ Aspect ratio

This is the size of the screen image measured by its width and its height. The two common ratios are 4:3 (standard definition) and 16:9 (widescreen). When shooting in widescreen 16:9 the director should always remember to shoot everything '4:3 safe'. This means the camera person will need to consider framing every shot central to the screen, to ensure viewers watching on standard non-widescreen televisions are not missing any of the essential action.

Today most television content in the UK is produced 16:9. Even if the content is to be broadcast on a network still using 4:3, it is advisable to shoot 16:9 to future-proof the material.

The basics

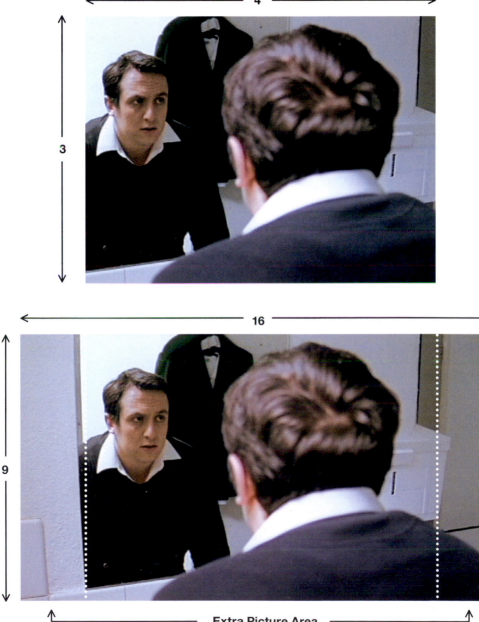

4

3

16

9

Extra Picture Area

Aspect ratios
The aspect ratio refers to the
size of the image on the screen,
measured by its width and height.

Being able to manage and deal with a budget is a necessary part of being a producer, and this next section will look at the fundamentals. A more detailed approach to budgeting for drama, documentary and magazine programmes will be explored in Chapters Three, Four and Five.

Early on in the production cycle, a preliminary budget can be drawn up in order to estimate the amount of money a project will need. This will outline broad categories, not specific details. Experienced producers and production managers are able to look at a script or proposal and judge how much the project will cost. This preliminary budget and production schedule will give an indication about when the project can start and finish, whether the project is viable and whether the people involved are experienced enough to handle it. It can also set the tone or visual style of the project.

A detailed budget will be drawn up at a later stage in development and pre-production. At this stage the proposal or the script will need to be broken down and an indicative schedule drawn up. As the script or proposal is developed along with the inevitable rewrites and drafts, the budget and schedule will change to reflect this.

/ **The basic principles**

The budget has to cover all three stages of the production process:

- **Pre-production**
- **Production**
- **Post-production**

In order to be able to budget and create a schedule for a production, the producer needs to understand what is required creatively and technically in order to achieve the finished product. The producer will always be working within the parameters of limited time and money.

Very early in the production the decision on which format to shoot on will have been made. Choosing the format to shoot on will be influenced by the nature of the project. For example, an observational documentary may well be better shot on a cheaper digital format rather than expensive film stock due to the amount of footage that will be shot during the production period.

Once the format has been selected, the producer will then have to estimate the quantity of raw tape or film stock that is affordable from the budget.

The amount of rushes shot in relationship to the length of the finished film is called 'the shooting ratio'. As tape is cheaper than film, a project using tape can afford to shoot more footage and is likely to have a higher shooting ratio.

The Blair Witch Project, 1999
If the idea, script, cast and crew for a project are all strong, even a relatively small budget can pay dividends. This was the case for *The Blair Witch Project*, which cost approximately $22,000 to make, but grossed more than $240.5 million at the box office.

Fundamental budget questions:
· How long is each stage of the production? Is it months, weeks or days?
· Who is needed, when and for how long?
· Can money be saved?

Shooting formats > **Budget** > Exhibition and distribution

/ The budget basics

The budget is a financial assessment outlining how much the film is actually going to cost. In development, the budget can be used to reassure potential investors. During production it may be used as the blueprint to gauge whether the project is on course or drifting into financial difficulties. A good starting point for a novice producer is to understand the structure of a budget. Essentially, every budget is split into two parts; these are the 'above-the-line' costs and 'below-the-line' costs.

Above-the-line costs are the script and rights, the producer, the director and cast. They are usually paid a flat, negotiated fee.

Below-the-line outlines all the costs needed to technically make the film. These costs are usually paid on a weekly or daily basis.

The budget should also have money set aside to cover any cost overruns. This is called 'contingency' and it is usually 5–10 per cent of the budget.

It is also essential that the budget includes money set aside to cover the cost of insurance. The insurance will need to cover both the equipment and fulfil the legal requirements of the production. University and colleges may well have their own policies to cover student productions.

A budget can run to many pages, each with complicated and detailed costings. The first, perhaps most important, page of the budget is called the top sheet (opposite page). This summarises at a glance the overall budget. It will show above- and below-the-line costs, subtotals of all production categories, contingency, insurances and finally the grand total.

Within the budget, each heading is expanded into a detailed budget, which breaks down the costs of each department or category with a subtotal. This will be explored in more detail in Chapters Three, Four and Five.

The budget top sheet
The budget top sheet summarises all of the different costs associated with a production. This covers above-the-line costs, below-the-line costs, and contingency.

Page 16

EP Budgeting
Budget Title :

Script Dated : Producer :
Budget Draft Dated : Director :
Production # : Location :
Start Date : Prepared By :
Finish Date :
Total Days :
Post Weeks :
Holidays :
Travel Days :

Acct No	Category Description	Page	Total
815	STORY AND RIGHTS	1	0
825	PRODUCER'S UNIT	1	0
835	DIRECTOR'S UNIT	1	0
845	CAST	2	0
855	ABOVE-THE-LINE FRINGES	2	0
	Total Above-The-Line		**0**
919	EXTRA TALENT	2	0
921	PRODUCTION STAFF	3	0
923	CAMERA DEPARTMENT	3	0
925	STILL PHOTOGRAPHY	4	0
927	ELECTRICAL DEPARTMENT	4	0
929	GRIP DEPARTMENT	4	0
931	PROP DEPARTMENT	5	0
933	PRODUCTION SOUND	5	0
935	WARDROBE DEPARTMENT	5	0
937	MAKE-UP AND HAIR	6	0
939	SPECIAL EFFECTS	6	0
941	SET OPERATIONS	6	0
943	STAGE/MOBILE UNIT RENTALS	7	0
945	SET DESIGN	7	0
947	SET CONSTRUCTION	8	0
949	MINIATURES	8	0
951	SET DRESSING	8	0
953	TESTS	9	0
955	2ND UNIT	9	0
957	PROCESS SHOTS	10	0
959	PRODUCTION RAWSTOCK & DEV	10	0
961	TRANSPORTATION	10	0
963	PROP VEHICLES & ANIMALS	10	0
965	LOCATION EXPENSES	11	0
966	PRODUCTION FRINGES	11	0
	Total Below-The-Line Production		**0**
967	EDITORIAL	12	0
969	MUSIC	12	0
971	PHOTOGRAPHIC EFFECTS	13	0
973	TITLES	13	0
975	POST PRODUCTION SOUND	13	0
977	LAB: FILM & PROCESSING	14	0
978	POST PRODUCTION FRINGES	14	0
	Total Below-The-Line Post		**0**
979	INSURANCE	14	0
981	PUBLICITY	14	0

/ Scheduling

As well as having to work out the budget, the producer needs to assess how long the project is going to take to shoot and then create a shooting schedule for each day. The producer can provide answers for these questions by breaking down the script or proposal into sequences.

The director will visualise how it is to be shot and these ideas are subsequently storyboarded or put into a shot list.

The producer can then consider these and produce shooting schedules as well as daily call sheets. There will be different strategies for drama, documentary and magazine programmes (these will be explored within Chapters Three, Four and Five).

The producer will continually be focusing on optimising time and saving money.

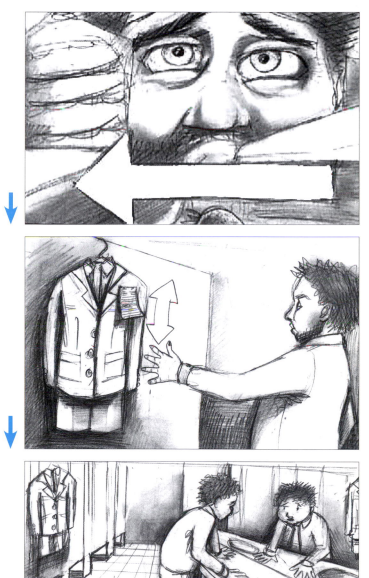

Storyboards
The director conveys how he or she visualises the film to the rest of the team through the use of storyboards. These can be used to inform the production process.

/ Factors that can affect the schedule and the budget

A primary responsibility of the producer is to plan and anticipate any problems that may delay or thwart the shoot or the shooting schedule. The producer should always think ahead and be able to plan for unforeseen eventualities. These are the type of things to look out for:

Weather

If the production involves shooting outdoors, weather can be a big factor when planning the shooting schedule. Cold, dark, wintry days mean that the working day will be much shorter than during the summer. Severe cold can also affect some of the equipment. In order to maximise daylight, it is advisable to shoot exteriors first before moving to an interior.

Access

As well as negotiating permission to film at a location, the producer will also need to assess the duration of each day's shoot. Other issues will also have to be addressed, such as: How easy will it be to transport equipment to and from the location? Is there access to power for lights? Are there any local catering facilities? Where are the nearest toilets?

Cast or participants

The producer may have to work within union regulations stipulating the length of the working day. Student film-makers will often find that they are required to fit their schedules around cast and crew member availability. These may turn out to be conflicting.

Children

Apart from strict regulations about filming with children and the length of hours they can work, children have a limited attention span and can lose interest over a short period of time.

Special effects and equipment

These will incur expense because of equipment hire, health and safety issues, and the need for additional crew. The shoot will therefore take longer due to setting-up time, rehearsal time and wrapping (finishing the shoot) etc.

Shooting at night

For a professional crew there are regulations about the length of a shoot and the scheduling of a day's shoot following straight afterwards. Night shoots or weekend shoots can be expensive and problematic, especially when shooting exteriors.

Extras

The more people involved, the more difficult the shoot becomes. Complex shoots also obviously have financial implications.

/ Call sheets

Once the shooting schedule has been confirmed call sheets will need to be prepared for each day of the shoot. The call sheet is a summary of all the essential details of cast, crew and location for each day's shoot.

CALL SHEET

PROD. CO: ...TITLE: BAXTER'S ISLAND
DIRECTOR: Laurence Park Timmons PRODUCER: Anita Lewton
Date: 27/01/05

		CALL SHEET NO	1
Director:	Laurence Park Timmons	**Date:**	SAT 27/01/05
Producers:	Anita Lewton	**Unit Call:**	
Unit Phone:	No mobile reception	**Breakfast:**	07.30
		On Set:	08.15
Unit Base:		**Estimated wrap:**	
		Sunrise/Sunset	8.20 / 16.42
Locations:	1. **LOC1 – LIVING ROOM**	**Weather:**	Max Day 8 Min Night 4
	2. **LOC2 – EXT. HOUSE**		Moderate, sunshine intervals

Loc No.	Set/Synopsis	Sc No	I/E	D/N	Pgs	Cast No.	Story day
1	LIVINGROOM.(MUTE) Alvin sits with newspapers.	2	I	N	1/8	1	1
1a	KITCHEN Martha prepares sandwich.	3	I	N	1/8	2	1
1a	KITCHEN (MUTE) Martha hears Alvin and Miles talking upstairs	5	I	N	1/8	2	1
1	LIVINGROOM Alvin and Martha talk about taking miles fishing.	4	I	N	2/8	1,2	1
1	LIVINGROOM.(MUTE) Alvin begins to write letter.	12	I	N	3/8	1	3
1	LIVINGROOM.(MUTE) Alvin continues to write the letter. Martha enters with tray.	15	I	N	3/8	1,2	3
1	LIVINGROOM.(MUTE) Alvin writes the final part of the letter.	17	I	N	1/8	1	3
1b	UPSTAIRS HALL Martha sorts through Miles' things	13	I	N	1/8	2	4
1b	BEDROOM Martha cries holding shirt/jumper.	16	I	N	1/8	2	4
1c	INT. HALL NYT Alvin on the phone talking	1a	I	N	2/8	1	1
2 (S/BY)	COUNTRY HOUSE. Light on in downstairs window Full moon shining/ trees / the peaks of hills	1	E	N	1/8	N/A	1

Sample call sheet

The call sheet is prepared by the producer for each day of the shoot. It provides a summary of all the essential details of cast, crew and location for each day's shoot.

Producers: Anita Lewton/Corazon Films and Conroy Park International

 Below is essential information needed by both the crew and cast:

· Contact numbers for all the crew
· The shooting location/locations for the day, with maps
· What is being shot each day
· Start time and the wrap (finish) time
· The location of first aid facilities and details of local hospitals

// Technology

Producers and production mangers can use computer budgeting and scheduling programmes that manage the process. It is worth looking at EP Budgeting and Movie Magic. However, the software is expensive and for a low-budget production a budget and schedules can still be drawn up manually.

For more information, see: www.entertainmentpartners.com.

// The production file

Organisation is essential for the smooth running of any production. Whether or not you have access to a production office, the producer will need to make sure the production is well organised. It's a good idea to keep a detailed production file for all the relevant paperwork. The producer should also ensure that all rushes/tapes are numbered, labelled and kept in one safe place. Ideally, this will be in the same location as the film is being edited. A logging notebook should be kept with them too.

Professional tips

// The production file should include sections for:
- Budget
- Location agreements
- Permissions and contracts
- Insurances
- Contact lists: to include participants, crew and other contacts
- Production schedules
- Call sheets
- Risk assessments
- Scripts and background research notes
- Post-production logging sheets, paper edits etc
- Publicity materials and images

Production file

The production file is an essential tool
in the organisation of the production.
It contains all relevant paperwork,
which can be easily accessed as and
when required.

Getting the project seen widely or distributed to as large an audience as possible is the final stage of the production process. Recouping the financial cost of making the project is an essential part of the producer's job. If a broadcaster or production company has funded the project, they will, in most cases, meet the cost of publicity and the marketing of the project. It is the producer's responsibility to make sure that the necessary contracts and publicity materials have been delivered along with the master tapes of the programme.

There are several ways programmes and films can be exhibited and distributed:

- **Theatrical:** this is another term for cinema release
- **Non-theatrical:** can include institutional markets where programming is needed for educational or instructional purposes, such as schools, prisons and libraries
- **Exhibition:** such as film festivals
- **DVD distribution**
- **Television:** network, satellite
- **Internet and other digital formats** – eg mobile phone.

The latter two markets are going through massive change and evolution, with TV and Internet platforms increasingly coming together to provide and deliver programme content.

SHELF LIVES

/ Multiplatform delivery

Broadband, mobile phones and other portable devices, websites, interactive gaming and developing media…

The start of this century has seen a revolution in the way that TV and programming is being viewed. The audience is no longer tied to the TV schedules, they can pick and choose what they want to see, where and when. Consumers can often be using several forms of technology simultaneously – a term called 'media stacking'. The conventional broadcasting of programmes is being redefined. Interactive and converging media platforms are opening up programme content and creating new ways of distributing it, not only for traditional broadcasters but for independent film-makers too. It is changing the ways in which content is being developed and produced. New creative strategies and processes are being developed to exploit this new technology for new markets and a highly fragmented audience.

The producer will need to have a creative, technical and business understanding of this changing environment.

The broadcaster may be in a position to sell their programme to other countries and territories. There are several international markets where the film and programme rights are bought and sold. The main ones are MipTV and Mipcom.

For the independent or student producer without a PR or press department behind them, the marketing of a film is a very different and often more difficult proposition. The most obvious markets to target are film festivals, TV stations and the Internet. The producer should be aware that if a film finds its way on to Internet sites, such as YouTube, which allow free access to the film, copyright issues may arise.

There are also specialist short film distributors who can be approached to handle the distribution of short films.

For further details see:
www.britishcouncil.org/art-film-festivals.htm
www.dazzlefilms.co.uk,
www.miptv.com and
www.mipcom.com.

Publicity
Publicity is essential for any production, and can take many different forms, such as this poster from *Shelf Lives*, which was distributed widely to publicise the film.
Producers: Amanda Jenks and Charlotte Worthington

· When making your own films always think about maximising publicity
· Shoot stills during production
· Make sure you have all the correct permissions
· Think creatively and use opportunities during production
· Start selling before you shoot
· Set up a website

Budget > Exhibition and distribution

Publicity

The short film is a calling card for many producers, directors and writers – a way to get their name and work known in the industry. Early on in the production the producer needs to be thinking about how to get the film noticed and talked about. In other words, publicity.

Publicity is essential for any production. Whatever the market, the project needs to have a viable publicity and marketing identity. It is a good idea to include some publicity costs within the budget. Also, engage a photographer to take stills of the cast and crew in action on the days of the shoot. Briefed properly, they will be able to capture key images, which can be used in publicity material such as press packs, posters and production websites. As well as organising stills, the producer will have to put together other publicity material or a publicity pack. Updated regularly, it is used to promote the film to distributors, film festivals and industry players. It can be either a paper copy, CD or an electronic press pack ready to be sent at the click of a button.

The following material should be in a publicity pack:

- Copies of copyright clearances, licences and contracts. A music cue sheet will be needed if commercial music is used in the film
- Technical details including the aspect ratio, running time and shooting format
- A transcript – the final script as seen and heard on the screen
- A credit list of complete cast and crew
- A short and long synopsis of the film
- A log line – a snappy one- or two-line summary
- A set of publicity images. Ideally high-resolution jpegs clearly labelled with the film title, scene and cast/crew names
- Other visual material, such as posters or flyers
- Any other information, such as awards
- Copies of the film with the title and contact details.

With hundreds of film festivals held across the world every year, the producer needs to research and enter the most appropriate for their project. For example, some festivals target particular groups, genres or themes, while others are accredited by the industry or other professional organisations. With the right strategy and by getting your film accepted at festivals, you can raise your profile, attract distributors and make contacts. It can be an expensive business, so the producer needs to have money to cover entrance fees, film copies and press kits.

For more information about distribution and marketing, see: www.withoutabox.com.

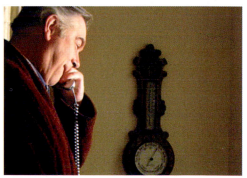

Publicity stills

These stills for *Baxter's Island* were
used as part of the publicity pack.

Producers: Corazon Films and Conroy Park
International, and Anita Lewton
Director: Laurence Park Timmons

Budget > Exhibition and distribution

PRODUCING DOCUMENTARY

The first two chapters of this book have been designed to lay down the basic building blocks needed to understand the role of the aspiring producer. It has been an attempt to sketch out the responsibilities of the producer's job. From this point onwards this book will explore in greater detail the producer's role in making documentary, drama and magazine-type content.

Chapter Three sets out to explore the producer's responsibilities, role and strategies when it comes to documentary production. It looks particularly at the principal aspects of professional production and how this may relate to student or independent production.

This chapter will also focus on the basic production knowledge required by a novice documentary producer. The complex areas of co-finance, finding project partners and negotiating international funding will not be addressed on this occasion.

It should always be remembered that there are many ways to tell stories and to make films. The following sections of the book are designed to offer a range of relevant information that the budding producer can apply to his or her own project.

Hair
There are many ways to tell stories and make films, and *Hair*, a short documentary about a London hairdresser, is just one of them.

Grey Gardens, 1975

Synopsis

Grey Gardens is a documentary, which depicts the everyday lives of Edith (Big Edie) Ewing Bouvier Beale and her daughter Edith (Little Edie) the aunt and first cousin of Jacqueline Bouvier Kennedy Onassis. The two women lived in squalor and isolation at Grey Gardens, a decrepit mansion in the neighbourhood of East Hampton, New York.

Susan Frömke

Susan Frömke is a producer, director and writer who has won numerous Emmy and Grammy awards for her work. Her career has spanned over 30 years, during which she has worked on both drama and documentary productions.

Most documentary production teams tend to be smaller than those needed for drama or magazine programmes. The main reason for this is that budgets tend to be smaller. Documentaries don't require an extensive crew. They don't need costume designers, art directors and technical specialists. Also, documentary styles, such as observational film-making, require small crews who are less intrusive and therefore more likely to develop an intimacy with the subject.

On a student or independent project, due to obvious financial constraints, the crew will tend to be small; it is even not unusual to have one person covering a multitude of roles.

The job titles are as follows:

EXECUTIVE PRODUCER

Can be a commissioning editor from a TV broadcaster or production company. Provides the finance for the film.

PRODUCER

Works with the director to get the film made. Answerable to the executive producer.

DIRECTOR

Key creative and editorial decision maker, sometimes taking on elements of the producer's role. Some directors work without a camera crew, shooting all their own material.

PRODUCTION MANAGER

Responsible for managing the budget and day-to-day running of the production.

RESEARCHER

Assists the director in finding key stories, participants and background information.

FIXER

From the local area where the filming takes place, providing detailed knowledge and access.

EDITOR

Assembles the film from the shot footage and works closely with the director.

Documentary production
Observational documentary
film-making requires only a small
crew and can comprise of as few
as one person. This allows a more
intimate exploration of the subject,
as well as making the most of the
financial constraints associated with
producing documentaries.

A producer should be aware that there are a number of different types of documentary film-making. He or she will need to have definite ideas as to the film's approach – the tone, style and focus of the developing project. The approach or style may be dictated by the film's market or the available slot on a TV channel.

Early on in the production process the producer should have a clear idea of the type of documentary being made. He or she will have firm ideas about subject matter, participants and shooting style. Another way of understanding this is to think of the approach; how the story gets to the screen and how the film is going to look.

There are of course many ways to tell a story and the documentary medium is constantly evolving. Although not a definitive list, the following illustrates the main categories:

- Sport
- Observational
- Science
- Travel
- Political
- Drama documentaries and reconstruction/recreations – docudrama
- Archival – using third-party or stock footage
- Historical.

Documentary styles
There are many different styles of documentary film-making. *Cage Fighter* is an example of a sport documentary (*see* Chapter Six: Learning Curves).

'Development Hell' is a well-known industry phrase that sums up the tricky part of any production, which is to root out a fresh and compelling story, pin it down and find the money to make it. This part of the production process very often requires tenacity, patience and nerves of steel as it can take a long time to get a project on the screen. Many projects never get beyond this stage and dealing with rejection is very much part of the process.

/ The idea

The first stage in the making of a documentary is to find and then develop an original idea. This is called the development stage and it is when the initial thought or concept is researched and transformed into an engaging proposal.

/ Research (or how to find your subject)

The crucial questions to be explored by the producer at this stage essentially centre around identifying the story and the key characters. Some questions that need to be answered are: Is the topic hitherto unexplored? Is it a familiar story with a new angle or new access?

The key to a successful documentary always depends on access, the subject, the depth of the background research and the way in which the emerging story is shaped.

Depending on the particular nature of the project the producer may or may not be closely involved in the initial research of the programme idea. If seed funding or development money becomes available, a researcher may be hired to unearth key information, locate key participants or identify key visual content, such as archive footage, newspaper articles or photographs. In this type of production situation the producer's role will be to manage the initial research, gather the relevant material and work with the researcher to hone it into a proposal and treatment.

Alternatively, the production team may include a researcher, a producer and a director at the early stages of a project. Each member of the team may be involved in the smallest detail and nuance of the research.

These preliminary stages of production research may take place across a broad range of avenues. The following is a checklist designed to help collate enough information to develop a well-researched documentary proposal:

- Organise research
- Develop and write a proposal
- Check access and rights to story/ characters where relevant
- Locate possible backers/ broadcasters.

Research
Materials, including notebooks, sketches and photographs, are essential tools when carrying out the initial research for a project.

> · **Seed funding** money for development, which may have to be paid back. Can be traded for a credit or percentage of any profits if the film is sold
> · **Researcher** this person will identify key contacts, sources and will verify information relating to the programme

**/ Research – where to go:
A producer's guide**

**There are a range of familiar places to
research background material:**

THE INTERNET

The World Wide Web can
provide easily accessible
and detailed information,
references and ideas.
However, some areas of
information are worth
double-checking for
accuracy and veracity
due to the nature of the
medium. The Internet can
also provide opportunities
to contact groups or talk
to people directly. Blogs
may also be a useful
resource to access (see
Chapter Six: Learning
Curves).

FILMS, TV ARCHIVE AND OTHER BROADCAST MATERIAL

Archive sources can
provide valuable
background information
and may help clarify
whether certain
individuals have been
the subjects of other
documentaries in the past.

DIRECTORIES, YEARBOOKS, ANNUALS AND DATABASE DOCUMENTS

These are useful sources
for finding people and
organisations. Yearbooks
will also indicate any
key events, anniversaries
and celebrations.

NATIONAL AND LOCAL NEWSPAPERS

Newspapers can provide
useful sources for
contacts and reference
material. Archive
libraries may provide
public access to
publications going back
two hundred years.

OFFICIAL PUBLICATIONS

Official documents
produced by governments
and other official bodies.
Most government agencies
and public bodies publish
comprehensive sources of
contemporary data and
statistics.

PARTICIPANTS

Identifying the appropriate person or people to participate in a documentary is obviously crucial. Finding credible contributors is critical to a project. This process can also be known as casting. In many ways there are similarities to drama. Both require interesting characters to tell the story - they are essential to how the story unfolds.

OTHER DOCUMENTARIES

A producer needs to be aware of the competition. Viewing a range of documentaries that have already been made is a useful research tool.

Starting point/tips

· The producer needs to know early on how easy it will be to involve people in the project. For obvious reasons high-profile participants tend to be more difficult to access and to film. They may demand some say over how their contribution is used during the editing process.

· The research may also involve experts in their field to highlight interesting and relevant information. This allows key ideas and perspectives to be presented in an accessible way.
· It is the job of the producer and director to turn often complicated and specialist knowledge into an entertaining and accessible programme.

Once the preliminary research has been completed the raw content can be developed into a proposal and then a treatment.

The proposal will be the key selling or pitching document for the project. A producer will always be required to explain the project right through to final delivery, but this is the stage when the pitch opens the door.

The proposal should always present what can often be complex or sensitive ideas, in a compelling way. The writing needs to be simple and direct. It should catch the eye, ear and imagination of whoever is reading it. It is a way of envisaging a film before it is made.

The proposal will include a description of the project, identify the key participants, and argue why the project should be made. The most important consideration for a producer when writing this document is that it needs to be compelling. It needs to tell a good story. It should also be remembered that, fundamentally, we are discussing a visual medium. The documentary is not merely a vehicle for a conversation or a lecture.

The proposal should indicate the length of the production period and outline any preliminary production plans. It should identify the intended audience and, where relevant, include any letters of support or agreements for contributors to be involved. This will help give an indication of the project's viability.

Alongside or within the proposal there should be a treatment. The treatment puts into writing how the project will look. On the screen, this will give a feel for the mood, shooting style, the locations and the contributors.

Starting point/tips

The initial proposal will clearly outline the idea and key contributors. Ideally the proposal will not exceed two sides of A4 (8x10) paper. The commissioning agent will often indicate the optimum length. Do not write more than two sides and be concise. However strongly you feel about the project, most commissioning editors have limited time and, in many cases, little attention span.

Running glossary

· **Treatment** a description of the documentary outlining the story and contributors while conveying its mood and tone
· **Pitch** a short and snappy summary of the project

Treatment

This film will attempt to highlight the realities of post-natal depression (PND) as told through the diary of a sufferer. Although the woman doesn't physically experience all the different theories behind the cause of the problem or the associated remedies, the film will, nonetheless, explore these and talk to the people behind them and those that have benefited.

Transmission
The film will be suitable for transmission to an evening audience on either BBC2 or Channel 4 – accessible science! The aim is to get away from the commonly held view that PND is either a trivial by-product of childbirth or a woman-only issue and to educate a wider audience about the social impact on the whole family unit – including men.

Treatment
The story will be told from a first-person point of view – with voices of different, anonymous women speaking – this could be extracts based on my diary.

It will be introduced at the beginning by X – she will talk about how her life has changed since the publication of her book and briefly introduce the viewer to her story. Despite X being one of the most 'high profile' sufferers she has never before agreed to go public about this intensely personal period in her life. The programme will take the form of a 'personal journey'. X will introduce post-natal depression from a personal point of view – the emphasis will be on the fact that this, for many women, is a very serious problem, more importantly it is a debilitating mental health problem that is experienced by a large proportion of new mothers and has serious knock on effects for the whole family unit. It is NOT feeling a bit weepy for a couple of weeks – it is day after day of unrelenting black tunnel from which there seems little chance of escape.

X will explain that far from this being a problem suffered by 'celebrities' complaining to a magazine that they can't get back into their size 10 jeans – the severest form of post-natal depression is the single biggest killer of women in the first year of their child's birth.

Y runs the [...] association, which runs a network of volunteers who counsel sufferers on the phone, by email etc. Y will explain some of the facts behind the illness and explode some of the myths. She explains how it can affect anyone, anytime – rich/poor, working/unemployed, large family network/single mothers. She will introduce us to [...] who has been a volunteer for eight years and she tells X how she approaches a depressed mother and the key issues that she wants them to believe.

I had approached Z to explain her theories of hormonal effect on post-natal depression – in her 'absence' Z can either discuss this herself or will approach the [...] doctor to step in. It is one of the cause/remedies that I would like to explore.

X will talk to a midwife from [...] Health Trust about the importance of ante-natal home visits in getting to know the woman BEFORE she has a baby; they are then a lot more able to make an informed judgement about her mental state after the birth.

Treatment
The treatment outlines how the programme will look on screen. It will give an impression of the mood, shooting style, locations and contributors.

Another important part of the producer's role is to draw up and attach an outline budget with the proposal and the treatment. If the producer is applying for funding, this will be an absolute requirement. The budget will show the producer is capable and experienced enough to be considered for funding. There will be situations where this may not be necessary, for example, the project may be developed within a TV or production company.

The indicative budget will cover the production costs. Drawing up a proposed production schedule showing how long the project is expected to take to shoot will help this process.

The basic principles of budgeting, as discussed in Chapter One: The Producer, should apply here.

There are several questions that need to be asked when drawing up the budget. These are:

- How long will each stage of the production take – is it months, weeks or days?
- How many shooting days are there?
- Who is needed?
- What is needed?
- Can money be saved?

Generally, a documentary budget tends to be less complicated than a drama budget. There are fewer elements to cost, smaller crews, less equipment and often less-complicated shooting scenarios. The budget will still be linked to a shooting schedule.

If you are writing up a budget, these are key elements to keep in mind:

Professional tips

/// The budget should cover all of the provisional stages:
- Pre-production
- Production
- Post-production

MISCELLANEOUS COSTS

You should budget for everyone and everything. If you don't, you may have to carry the cost out of your own pocket. These costs may include:

- Telephone
- Photocopying
- Travel
- Copies of the finished documentary
- Tape cost, including the shoot and masters copies of the completed documentary
- Insurance

COPYRIGHT

On a low- or no-budget documentary the cost of clearing a piece of music or footage can be prohibitive. For instance, if you use music in the film and haven't cleared it you could find yourself in serious trouble. Alternatively, a specially commissioned piece of music may prove cheaper and may help market your product.

EQUIPMENT

Even if you know you can get a good deal on equipment or a location for little or no cost, enter a costing in the budget. Any money saved can be used elsewhere in the project. It pays to be flexible.

OTHER COSTS

Always feed the crew and participants properly on the shoot. It shows respect and encourages the crew to work hard. Also, offer to pay travel costs - up to a limit.

PUBLICITY

Always put something in the budget for publicity. This will cover the cost of stills and posters to publicise the film. Website publicity, flyers and invitations to screenings all help. This is one area the novice film-maker tends to overlook.

FILM FESTIVALS

Try to remember to put something in for film festival entry fees and DVD copies.

YOUR TIME

Pay yourself, even if it's only a nominal amount. Even if you own your own equipment enter at least a cost for insurance as well as wear and tear.

budget.xls

	Programme Budget	Schedule 4
Schedule Ref.	Direct Costs & Overheads	Total £ Sterling
5	Story/Scripts/Development	#REF!
6	Producer/Director	#REF!
7	Artistes	#REF!
8	Presenter/Interviewees etc.	#REF!
9	Production Unit Salaries	#REF!
10	Assistant Director/Continuity	#REF!
11	Crew-Camera	#REF!
12	Crew-Sound	#REF!
13	Crew-Lighting	#REF!
14	Crew-Art Department	#REF!
15	Crew-Wardrobe/Make-up/Hair	#REF!
16	Crew-Editing	#REF!
17	Crew-Second Unit	#REF!
18	Salary & Wage Related Overheads	#REF!
19	Materials-Art Department	#REF!
20	Materials-Wardrobe/Make-up/Hair	#REF!
21	Production Equipment	#REF!
22	Facility Package Arrangements	#REF!
23	Studios/Outside Broadcast	#REF!
24	Other Production Facilities	#REF!
25	Film/Tape Stock	#REF!
26	Picture/Sound Post-Production-Film	#REF!
27	Picture/Sound Post-Production-Tape	#REF!
28	Archive Material	#REF!
29	Rostrum/Graphics	#REF!
30	Music (Copyright/Performance)	#REF!
31	Travel/Transport	#REF!
32	Hotel/Living	#REF!
33	Other Production Costs	#REF!
34	Insurance/Finance/Legal	#REF!
35	Production Overheads	#REF!
36	Theatrical Performances	
37		
38		
	Total Directs Costs and Overheads	#REF!

Budget
The costs attached to the production should be worked out on a weekly or daily basis. At the top of each page will be the following headings:
Amount (days or weeks).
Units (how many days or weeks is the equipment or person hired for?).
Rate (the daily or weekly cost of the person or equipment hire).

How is a shooting schedule produced?

Documentary schedules will generally be built around key days/events and the availability of the contributors. These set dates will be the building blocks around which the rest of the shooting will take place. The producer should aim to maximise the potential of each full day of shooting. Usually, the crew and equipment will be hired on a daily basis.

Sources of finance

As well as the broad list of source funding outlined in Chapter Two: The Basics, there are specific organisations and resources that deal specifically with documentary films within the UK. DFG Docs (www.dfgdocs.com) is a good starting point and has links to documentary associates across the world. For European information, visit the European Documentary Network (www.edm.dk).

The Documentary
Speaking in Tongues Ltd

Shoot Day No.	1		
Date / Day:	01-Jul-08		
Crew Call:	7.00 am		
First Shot:	9.00 am		
Wrap:			

Cast & Crew	Start		Finish
Call Time			
Breakfast			
Lunch			
Dinner			
Wrap			

Shot List

Shot #	Scene #	Type of Shot	Set up time	Shoot time	On Line Description

Shooting schedule
The shooting schedule will be worked around key days, events and the availability of contributors.

Once the proposal has been accepted and the money is in place, the project will enter the next phase – pre-production. The producer will need to ensure that all the detailed research is being progressed and is being taken into account within the production treatment and proposed shooting schedule.

At this stage of production the people most likely to be involved are the producer, a researcher and the production manager. A director may also be closely involved during the research stage.

/ Key stages for the producer

At this stage the producer will need a base from which to work and so will need to find and set up a production office. Filing systems will need to be set up for various elements of the production as well as ensuring that ongoing research is taking place and detailed notes are being kept by the researcher. It will also be necessary to ensure that access and any rights are negotiated well in advance of the shoot where possible. The types of rights that need to be considered are:

- Archive clearances for film
- Clearances for photographs
- Access rights to public events, such as sporting events
- Story rights if dealing with individual contributors.

Location agreements are also a necessary part of the pre-production process. If it is vital that certain scenes are shot in particular locations it may be necessary to get access in advance. This will also apply if the film is to be shot in places that need specific permission, such as schools, prisons, hospitals or sports grounds.

/ Building relationships

The importance of building trust and nurturing contributors cannot be overstated. Reassuring participants and helping them to be comfortable with the camera is also important. The producer will need to make sure someone takes responsibility for this. This may mean making several visits to locations with the participants without a camera, chatting and observing day-to-day events and group dynamics. This is part of an ongoing process. It may also identify important new information, which may need to be added to the shooting schedule.

/ Hiring key members of the crew

Documentary crews are usually very small and often number no more than a camera person and sound recordist. Some producer/directors are able to direct and shoot the project themselves. This approach will usually be adopted where intimacy and immediacy is of paramount importance. A small crew is obviously less intrusive. Alternatively, some projects may require a larger crew, such as a long-running series.

/ Booking travel and hotel arrangements

If the project involves shooting abroad or takes place in multiple locations away from the production office, travel and accommodation will need to be taken into consideration. This will have to be planned alongside the shooting schedule.

/ The production file

The production file is vital for the smooth running of the production. See Chapter Two: The Basics for more detail.

Crew
Documentary crews are usually very small, and it is not unusual for one person to act alone.

A feature of some factual and documentary productions is that the go ahead for filming can happen very quickly, often as a response to events. An experienced producer/director will be able to quickly step in and get the job done. Of course, there are other productions where the run into production allows more time for preparation. Whatever the situation, the key to a successful production is planning.

/ The script

At some stage in the pre-production and production processes all the research will need to be collated and shaped into a programme structure. Initially this may take the form of an outline script. Depending on the type of documentary there may also need to be a commentary or voice-over (V/O) written. For some types of documentary the V/O may well be crafted early in the project, for others films the V/O will be written during post-production.

The script can be written in the form of a traditional screenplay or in a double-column format where the page is split in half. The right-hand side will describe the audio and the left-hand side will describe the visuals. Audio may include commentary, dialogue, sync sound, voice-over and music.

Software programmes may help, such as Final Draft AV (www.finaldraft.com), which provide templates with which to work.

Shooting on location
The go ahead for filming a documentary can occur very quickly. It is important that the producer/director is able to act quickly on this to get the job done.

/ Paying contributors

Commonly interviewees are not paid. The issue of paying contributors needs to be considered on a case-by-case basis. In an ideal world the participants will take part to get their voice or stories heard. An initial decision not to pay a fee may have to be revised because of changing circumstances. Ideally, contributors who are paid for their time and expenses should not be led to believe that they are entitled to editorial control over their appearance. Some producers may offer payments in kind, such as making donations to a charity.

If an expert is involved behind the scenes of a production (such as an academic or a scientist) it is not uncommon to pay a small fee for their time and expertise.

Final Draft AV
Software programmes, such as Final Draft AV, provide templates, which can be used to create the script. (www.finaldraft.com)

Final Draft AV File Edit View Insert Format Tools Window Help

arctic.xav

Save Print Cut Copy Paste Insert Video Insert Audio Scene/Shot Current Element Dialogue

- 1 -

Agency	MM Worldwide Group		Writer	Gerald Franks
Client	Unadventurer's Inc.		Producer	Cameron Ford
Project	VC-4X		Director	Steven Donovan-Lee
Title	*Arctic Escape*		Art Director	Dave Sharpe
Subject	Life in the Northern Wastes		Medium	HD
Job#	76D		Contact	M. Belle
Length	24 mins		Draft	7B-AD

VIDEO	AUDIO
§ OPEN ON DESOLATE ARCTIC WASTELAND, VARIOUS SHOTS	JIM: (REVERENTLY) THOUGH IT SEEMS UNLIKELY, THE ARCTIC CONTAINS ALL KINDS OF WILDLIFE. JANICE: THIS HARSH ENVIRONMENT IS HOME TO A WIDE DIVERSITY OF ANIMALS.
§ (MONTAGE) VARIOUS SHOTS OF CARIBOU HERDS IN MOTION	JIM: CARIBOU MIGRATE OVER GREAT DISTANCES
§ VARIOUS SHOTS OF SEALS ON ICE AND BELOW	JANICE: SEALS FROLIC ON ICE FLOE AND BELOW THE SURFACE.
– MOSQUITOS SWARM	JIM: SWARMS OF MOSQUITOS AND BLACK FLIES TAKE ADVANTAGE OF THE ALL-TOO-BRIEF SUMMER.
§ MCU JIM & JANICE ON ICE FLOE	JANICE: WELCOME TO THE ARCTIC! THE LONG ARCTIC WINTER HAS BEGUN. JIM: ALL THE ANIMALS - ON BOTH LAND AND SEA

1 of 1 Dialogue [Tab] Next Video Description [Return] Dialogue

/ Copyright and clearances

The producer must always be in control of the production content. He or she must be aware of any corporate logos, background music or contributions, which may require clearance. Where possible any background music should be turned off. There will be occasions, such as public events, where this will simply be impossible. This will usually be deemed as incidental music. However, it is best to be aware that this is a complicated legal area and if in any doubt stop filming or get legal advice before you start. Should something slip through the net, expensive post-production costs may be incurred requiring the blurring of faces or logos etc. Avoid this by heading off problems before they arise.

Permission
It is essential that the producer collect signed permission forms from all contributors. Failure to do so will mean that any footage shot will be useless.

Starting point/tips

Things to remember when preparing to film:
- · Ring tones on mobile phones: turn off all phones
- · Video and computer games: make sure the camera is not pointing at the screen

- · TV programmes: as for video and computer games
- · Logos on clothing and hats – approve in advance what people are wearing, or get them to change
- · Logos on products – avoid them in shot

/ Release forms

- PERMISSION
- PERMISSION!
- PERMISSION!!

The producer should always ensure that release forms are signed wherever possible before the shooting begins. Persuading contributors to sign forms after the shoot can be a nightmare. An unsigned form means that the footage cannot be used.

There will be situations where it is difficult to get permission of individuals en masse – such as in a crowded place like a park or a nightclub. The way round this is to put up signs indicating that filming will be taking place, and that if people do not wish to be shown they need to tell a member of the crew. The sign should be filmed at the same time.

Public spaces
The producer must check the rights to shoot on location. Even in public spaces, consent to film still has to be given. This is the case for Greenwich Park, London where consent has to be granted by The Royal Parks.

/ Vox pops

Vox pops (Latin for 'voice of the people') are unrehearsed interviews or expressions of opinions that take place in public places. They are intended to give a feeling of spontaneity. Children will need the written permission of their parents or guardians.

/ Location agreements

The producer must ensure that any access or location agreements are negotiated and signed, ideally before the shoot starts.

Locations
Filming for a programme can take place in a range of locations.

Location Release Form

(Name) _____ ["Owner/Representative"]
(Telephone) _____ (Address)

Owner hereby grants to [_____] ("Company/Producer") and its respective parents, subsidiaries and affiliates, licensees, successors and assigns, for good and valuable consideration, receipt of which is hereby acknowledged, permission to enter upon and use the property and the contents thereof and the appurtenances thereto located at _____ (the "Property") for the purpose of photographing and recording certain scenes in connection with a programme tentatively titled _____ (the "Program"). All physical embodiments of filming, recording and photography on the Property shall hereinafter be known as the "Materials".

Company and/or Producer may place all necessary facilities and equipment on the Property and agree to remove same after completion of work and leave the property in as good of condition as when received.

Company and/or Producer will use reasonable care to prevent damage to said Property, and will indemnify the owner, and all other parties lawfully in possession of said Property, and hold each of them harmless from any claims and demands of any person or persons arising out of or based upon personal injuries, death or property damage suffered by such person or persons resulting directly from any act of negligence on Producer and/or Company's part in connection with Producer and/or Company's used of the Property.

Owner grants to Producer and/or Company all rights of every kind in and to the Materials including without limitation the right to exploit the Materials throughout the world, an unlimited number of times, in perpetuity in any and all media, now known or hereafter Invented, and in connection with the Programme, Company or otherwise and for advertising and promotional purposes in connection therewith and all rights, including copyright in the Materials shall be and remain vested in Producer and/or Company, and neither the Owner, nor any tenant, nor other party now or hereafter having an interest in the Property, shall have any right of action against Producer and/or Company or any other party arising out of any use of said Materials whether or not such use is, or may be claimed to be, defamatory, untrue or censorable in nature.

The undersigned acknowledges that Producer and/or Company is photographing and recording such scenes in express reliance upon the foregoing. The undersigned represents and warrants that the undersigned has all rights and authority to enter into this agreement and to grant the rights granted hereunder.

Producer and/or Company are not obliged to actually use the Property or produce the Programme or include the Materials in the Programme for which it was shot or otherwise.

This is the entire agreement. No other authorisation is necessary to enable Producer and/or Company to use the Property for the purpose herein contemplated.

AGREED AND ACCEPTED

BY _____

DATE _____

Location release form
All location release forms must be organised and signed before filming takes place.

Once the footage has been shot, the project will go into post-production or the editing stage.

Often in the case of documentary film-making many hours of footage will have been shot. These tapes will have to be logged and then digitised before editing the programme can begin.

The role of the producer during post-production will vary with each production. Some projects will have several key members of the production team – a producer, a director, an editor or a combination of these, sitting down to view rushes. At other times the editor alone will view the raw material in order to get a feel for the project. He or she may cut rough sequences together before showing the producer or director. There are many ways to tell stories and many ways to approach a production.

Once the film has been edited the next stage of post-production will be the sound dub. Here the voice-over (V/O) will have been written, recorded and added to the soundtrack.

/ Delivery, exhibition and publicity

Once the editing of the documentary is finished and master tapes have been made, the project enters the final stage of the production process. There are still aspects of the production that have to be dealt with, including making publicity copies on DVD.

As well as dealing with this the producer will also be tying up loose ends and closing down the production office/base.

For further information on funding, distributing and screening documentaries see:
www.britdoc.org,
www.channel4.com/fourdocs,
www.edn.dk and
www.mipdoc.com.

Professional tips

// Post-production paperwork includes:
· Logging sheets
· Commentary scripts
· Final scripts/programme as completed transcripts from the script
· Music cue sheets
· Final collating of licences, permissions and contracts ready for delivery
· Final budget costing

Editing
The post-production or editing stage occurs when all of the footage is viewed and sequences cut together to produce the final programme.

/ James Dawson

James Dawson is an award-winning documentary film-maker who has worked for the last 15 years for all the major UK terrestrial channels, including the BBC and Channel 4.

What do you do?

I'm a producer/director. I work on a variety of factual programmes, but mainly documentaries. I've made films about the NHS, overweight children, fishermen and strange phobias. I shoot a lot of the programmes I make myself so am also called a Shooting Producer Director. I started out as a camera assistant working on pop videos and dramas. I came up with an idea for a documentary and sent it in to Channel 4, who commissioned it. Realising that I enjoyed making documentaries I sent some more ideas to an independent production company in London and they gave me some work as a researcher.

Who are the other members of the production team?

Most of my work takes place with just one or two people. Either I work with a camera operator, sound recordist and an assistant producer, or I use the camera and have a sound recordist and assistant producer. The smallest unit is just me and an assistant producer who does the sound recording. Normally the production company will have a production manager overseeing the budget, booking hotels, flights, etc. Working as my boss will be either a series producer, overseeing the delivery of a series, or an executive producer if it's a smaller-scale production.

What other types of producer do you work with?

In TV 'producer' is a very broad term. Mainly it means the person responsible for making sure that a production is delivered to the broadcaster. They work with directors who are responsible for the editorial direction of the programme. I am a producer/director so combine both jobs. Producers tend to be in the background making sure the budget isn't blown and that the whole thing doesn't come off the rails. However, in some areas of factual TV a series producer has a lot of editorial input and often will intervene in editing and in the planning of productions at every stage. How you define a producer generally depends on what area of TV you are working in.

Can you talk more abut the programmes you work on, how they get funded and your role as producer?

Most of the programmes I have worked on are made by the independent sector for broadcasters. They come up with ideas and pitch them to broadcasters who decide to commission them. Once they've agreed what they want they start the process of making the programmes, employing people like me to make them. I work with researchers to find the stories to film. Normally the broadcaster funds the programme entirely and buys the right to show it several times on British TV and abroad. Nowadays independent production companies retain some of the rights to the programmes they make. This has meant a whole new stream of revenue to independents, which has turned some into large scale businesses.

'IN MY JOB YOU NEED A GOOD SENSE OF WHAT A STORY IS AND HOW IT CAN BE TOLD.'

What are the most important skills needed for your job?

In my job you need a good sense of what a story is and how it can be told; be able to think how you are going to film something, be good at thinking in pictures and in ways of telling the story which bring out its drama. You also need to be able to manage your team and the contributors you're filming, and you need to be able to translate all this material into an edited programme. The last part is the skill that's hardest to learn.

What is a typical week for you? Is there a typical week?

Depends on whether I am researching, filming or editing. The joy of the work is that it is varied. You can be all over the place doing different things from one week to the next. Generally much of the research is office based combined with visiting locations and possible contributors. The filming is on location and the editing is somewhere normally where the production company is based.

What can go wrong?

Lots can go wrong. You're dealing with people and they're unpredictable. That said you are normally following a real situation and as long as you anticipate things going wrong it's OK. You have to be able to make the most of a filming situation as it doesn't always turn out how you hope or anticipate it will.

Any tips for documentary film-makers?

Think about how your film will start. List the images you envisage. Think about how the film might end – it's easy to assume that it will have a natural end, but if you think about it then you can do some planning. An old producer once said keep things 'tight and loose'. Be well organised and prepared to the point where everything is anticipated and prepared for; then when you are filming you'll be able to follow whatever you want spontaneously.

Post-production > Case study: The producer/director

PRODUCING DRAMA

We've looked at the starting points for producing documentary, now we'll move on to explore the issues involved in drama production. As in the previous chapter we will focus on the key information needed by an inexperienced producer, and outline a producer's responsibilities, alongside industry roles and procedures.

There will be points in this chapter where areas of production advice may feel familiar, as they have been discussed earlier in the book. This repetition is intentional to drive home the core production skills needed by a producer across all types of projects.

Making drama is tough and challenging. With little or no money, it takes a passionate and committed producer to put the story successfully on the screen.

Drama production
Making a drama production, often with little or no money, is a challenging process. Nonetheless, it is a very rewarding one for the committed producer.

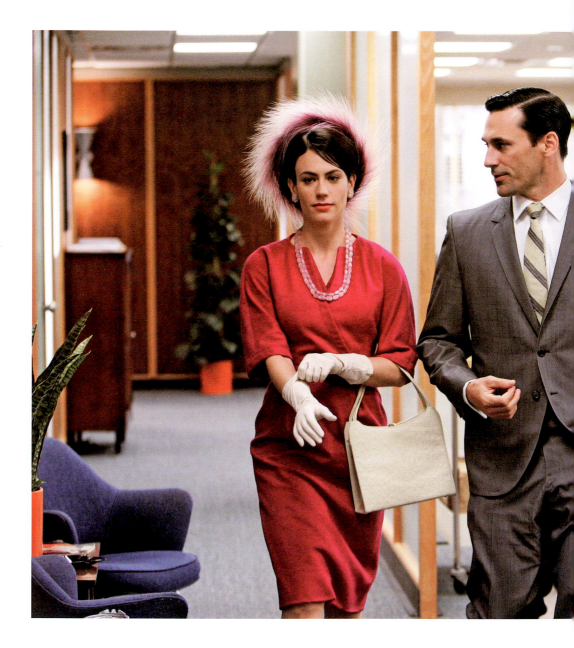

/ Mad Men, 2007

Synopsis

Mad Men is an American television drama series set in New York. It takes place during the 1960s in the fictional Sterling Cooper advertising agency. It centres around the high-flying advertising executive, Don Draper, as well as the people in his life both inside and outside the agency. The series also reflects the changing social conditions of 1960s America.

Matthew Weiner

Matthew Weiner is a producer, screenwriter and director who has won several awards for his work on productions including *The Sopranos*, *The Naked Truth* and *Becker*. Weiner acted as show runner, executive producer, and head writer of *Mad Men* for its first season.

Producer greats: Matthew Weiner > The team

Filming even the humblest, lowest-budget drama can involve managing a small army of people. In comparison to most documentary production, the drama producer will need to organise and manage a significantly larger production team and crew, as well as handling complex technical considerations. Once writers, agents, actors and composers are factored in, the drama producer's job is complex and layered.

The opening and closing credits of a drama highlight this complexity, as many productions often include several different producer titles. Some of these titles are more likely to be found in feature films than lower-budget digital productions.

Below are some of the key roles:

PRODUCER

Has overall business (budget, contracts), creative (script editing) and quality management responsibility for the programme. He or she controls the budget and hires the key creative members, such as the director, art director and editor of the production team.

ASSOCIATE PRODUCER

Will work under the guidance of the producer.

EXECUTIVE PRODUCER

May oversee several productions at one time.

CO-PRODUCER

Can be a producer from a partner in the funding of the project.

LINE PRODUCER

Normally found on feature-length film production. Employed during production to keep the project on budget.

DEVELOPMENT PRODUCER

Nurtures and develops a project with a writer, and pitch for funding. A development producer will be continually looking for new talent and ideas, reading scripts by new writers, searching out up-and-coming actors and watching short films by new directors.

Production crew

In addition to the various categories of producer, a typical drama will need a production team and crew dedicated to delivering a range of technical and creative skills. A big-budget feature film will have an extensive number of people involved in translating a script into a screen feature, but even a modest production will have a significant number of people involved throughout the production.

A basic guide of the production crew and their roles is as follows:

DIRECTOR

Responsible for the overall creative vision and the performance of the actors.

1ST ASSISTANT DIRECTOR (1ST AD)

Works closely with the director and the producer to ensure the schedule delivery and discipline on-set. Manages all the day-to-day production practicalities, allowing the director to concentrate on his or her job. Responsibilities include producing shooting schedules, keeping the cast moving and supervising the 2nd and 3rd ADs.

2ND ASSISTANT DIRECTOR (2ND AD)

Prepares call sheets from the shooting schedule and liaises with actors, ensuring they are on-set at the right place at the right time.

3RD ASSISTANT DIRECTOR (3RD AD)

Provides support to the 1st and 2nd ADs. He or she coordinates extras, is involved in crowd control and may also be responsible for security on the set.

SCRIPT SUPERVISOR OR CONTINUITY SUPERVISOR

Responsible for continuity and keeping track of what has been shot so that when the film comes to be edited everything makes sense. Polaroid or digital images from each scene may be taken for reference.

/ Camera department

Headed up by the director of photography (DoP), this department realises the director's vision. The DoP will be highly skilled, resourceful and able to bring his or her own creative input as to how a shot should look.

THE DIRECTOR OF PHOTOGRAPHY (DOP)

Works closely and directly with the director as it is the DoP's responsibility to capture the director's vision. He or she will make creative suggestions regarding lighting and camera angles, but in most cases does not actually handle the camera.

CAMERA OPERATOR

Answers to the DoP and is responsible for the working and handling of the production cameras.

FOCUS PULLER

Makes sure the camera is set-up with the correct lens and that each image is properly focused.

GRIP

Responsible for handling most of the non-camera equipment, including dollies, camera platforms and cranes.

GAFFER

Responsible for leading the electrical department. A DoP will often choose the gaffer. Responsibilities include managing generators, lighting trucks and setting up the lights.

RIGGERS

Specialist equipment is handled by specialist roles, eg crane operators.

SOUND RECORDIST

Ensures that the sound recording is consistent and constant on-set. It is his or her job to anticipate and solve any problems involving the quality of the recorded sound.

/ Art department

The art department is headed up by the production designer. This role is responsible for the creation and execution of specific production ideas and designs. The art department may include prop builders, scenic artists, make-up and wardrobe.

Production designers create the designs and drawings of the sets and locations. After reading the script, they will meet with the director and present ideas for the overall look of the film. They will also liaise closely with the director of photography (DoP).

As well as having to work with the DoP and their team, the producer will also be closely involved with the production designer and the art department, who are responsible for the creation and execution of specific production ideas and designs. The production designer will read the script and then meet the director to present concepts for the overall look of the film. Various members of the art department then realise the creative vision.

PROPS DEPARTMENT

Provide and place all necessary props for the scene.

SET DECORATOR

Works under the production designer to build the sets or to dress the location.

HAIR AND MAKE-UP

Get the actors ready for filming and provide any touch-up needed during the shoot.

ART DIRECTOR

Can be one and the same person as the production designer.

COSTUME DESIGNER

Designs and makes the costumes. Alternatively they choose the characters' wardrobe.

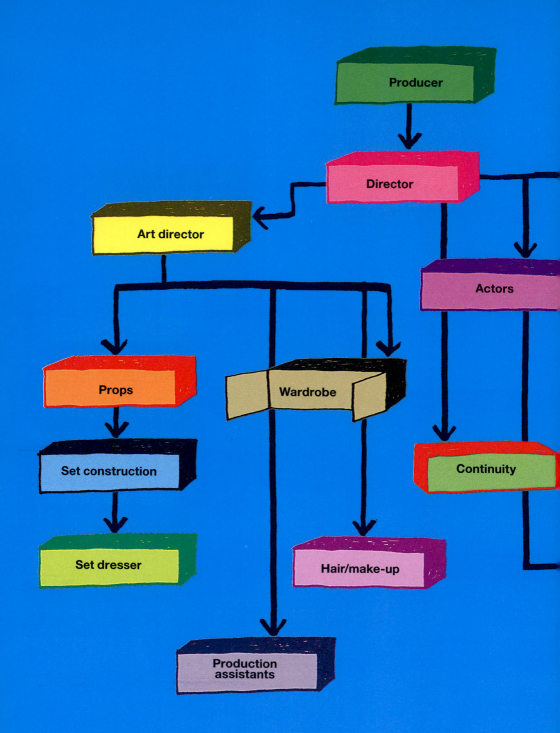

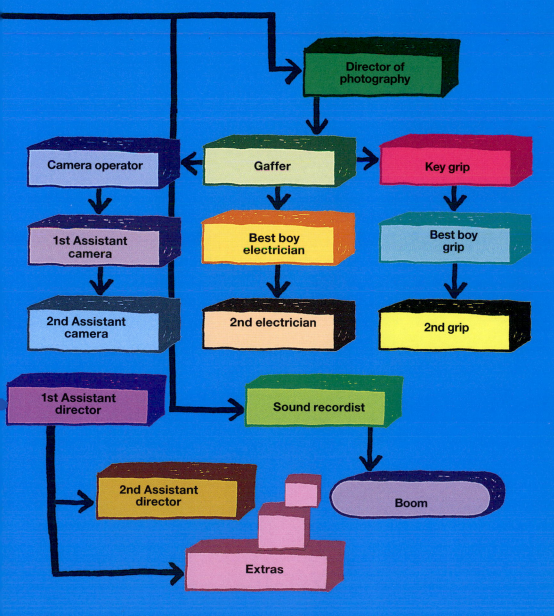

A story or idea for a film may come from a newspaper article, a book, a biography or simply from the imagination. It is at this early stage that the producer must negotiate and secure relevant rights. If the script or story already exists, the producer must identify ownership and acquire the rights to the material. Depending on the project this can involve approaching and negotiating with a range of people including lawyers, writer's agents or publishers.

Some literary works are already in the public domain because copyright has expired and therefore can be used without the worry of copyright infringement. Much classic fiction tends to be free of copyright. The bottom line is that the producer will have to make absolutely sure they can use a book, story or script in the early stages of development.

/ Working with writers

Without the writer there is no script and therefore no film. The first person the producer will have to work with is the scriptwriter. If the drama producer is the catalyst for the idea, he or she will need to find a writer to attach to the project and to develop the idea.

For a project to be successful the relationship between the writer and producer is pivotal. Understanding how the writer works, good communication and creative collaboration will enable the producer to nurture the story into a viable script to pitch to funding sources. When developing an idea with a writer, an agreement needs to be formalised in writing early on to avoid any disputes at a later stage.

Writing a script is often a lengthy and intense creative process. It may involve in-depth research around a specialist subject, as well as interviewing useful contacts. There can be many drafts before the final script is ready to be filmed. Desperate to get their hands on the camera and start shooting, inexperienced film-makers can overlook the attention to detail and time needed to craft a strong script. Ultimately, the script is the blueprint for the finished film.

As discussed in earlier chapters (see Chapter 2: The Basics) copyright and other rights issues can be complex. The drama producer requires in-depth knowledge or a budget to cover specialist legal advice.

For further information see: www.writersguild.org.uk, www.wga.org and www.wgwast.org.

Treatment
The treatment is written in order to convey the story and provide a feel for the film's mood and style.
Copyright: Momoko Abe

ALL IN THE DANCE TREATMENT

PROLOGUE:

A GIRL (soft and long brown hair, white skin, aged early 20) in a pretty white summer dress is walking through the lively Borough Market. She is listening to music on her iPod. The music leaks slightly into the air. She is quietly humming to the music. We don't see her face clearly, just her rosy lips stretched sideways. The way she walks suggests that she must be heading to a date that she has been looking forward to for sometime. She absorbs the lively noise of the market, the appetizing sight and smell of food.

HARRY & SALLY:

The GIRL is now in the National Gallery, looking at paintings. She finds HARRY (early 20s, black, slender) who is admiring the art next to her. There is SALLY (early 20s, Asian, brunette) on the opposite side of the quiet room. She is also looking at paintings. They move slowly from painting to painting. They are totally absorbed . The GIRL sees HARRY and SALLY bump into each other. They gasp and freeze. Their eyes are fixed to the other's eyes. The GIRL imagines that something starts sparkling inside of them.

Shiny golden yellow light wraps around them. They dance with wonder, a chemistry. They turn, lift, jump and feel dizzy. It's inexplicable feeling. Quiet but strong… like silent fireworks.

The GIRL comes to her senses. Everything is back to normal. HARRY and SALLY quickly and awkwardly turn their eyes away. GIRL sees that SALLY leave and HARRY watches her back as she goes.

JIM & CATHERINE & JULES:

It is evening and there are many people out in Piccadilly Circus . They are like bugs swarming to the bright neon signs. We find the GIRL chatting with a friend at the counter in a hip bar. The GIRL finds CATHERINE (mid-20s, petite, short hair, pretty) who is sitting alone on a couch, apparently waiting for someone. The next moment, JIM (mid-late 20s, handsome) appears with 2 glasses of red wine in his hands. A charming smile is on his face. He sits down next to CATHERINE and puts his arm around her shoulder without hesitation. While they are making out, another man runs into them. It's JULES (mid-late 20s, good-looking, stylish, unmistakably gay). He shows a genuine surprise to see JIM with CATHERINE. JIM notices JULES and freezes and his face turns to white. CATHERINE looks at JIM to JULES in confusion. The GIRL is watching those three in this awkward situation and imagines…

1

EXT. BOROUGH MARKET. DAY. 1

A GIRL in a pretty white cotton summer dress is walking
through the lively Borough Market. We glimpse her through
the gap between the stalls. She is about 21-23 and has
pretty dolly face with soft and long blond and fair skin.
She walks with slight hasty steps. Her skirt lightly
flutters as she walks. She is listening to music on iPod.
The music is slightly leaking into the air. She is quietly
humming to the music. Her cheeks and lips are rosy and her
face is beaming with smiles. she doesn't pay any attention
to either the lively noise of the market or the appetizing
sight and smell of food. She leaves the market.

INSERT:

A white text over black background: **HARRY & SALLY**

EXT. NATIONAL GALLERY. DAY. 2

The facade of the National Gallery where people come and go
and sit down. It's nice and sunny day.

INT. GALLERY. DAY. 3

The GIRL is looking at a painting in a quiet room. She looks
impressed. She turns her head and notices HARRY (in early
20s, slim, in smart casual outfit) who is admiring another
painting next to her. He nods slowly at the painting. There
is SALLY (in early 20s, skinny) on the opposite side of the
room. She wears a belet and colourful T-shirt. She is also
looking at paintings keenly. HARRY and SALLY move slowly
from painting to painting. Their eyes are fixed to those
arts in front of them while walking. The GIRL watches those
two unconsciously get closer and closer and finally bump
into each other. They gasp and freeze. Their eyes are fixed
to the other's eyes. The GIRL imagines that those two fall
in love with each other.

DANCE:

There are only HARRY and SALLY in the room. Shiny golden
yellow light wraps around them. They start dancing
Contemporary from the exactly same position where they
freeze. They dance with wonder for the inexplicable
chemistry. They turn, lift, jump to express the fizzy warm
inexplicable feeling. They finish in the exactly same
position as the beginning.

 (CONTINUED)

/ Development of a script

There are several key stages to the development of a script. These are the basics:

Treatment

Before the script is drafted the writer must first create a treatment. This will tell the story and also give a feel for the project's mood and style. After pitching and receiving a positive response, the producer and writer will then need to develop a draft script. The treatment should be seen as the first stage on the journey of putting the script on to the screen.

The proposal

In some cases the producer may present a raft of ideas to a drama commissioner, which may be pitched verbally. If any interest is expressed the ideas will then be developed into a written proposal or treatment. In other situations the producer will present a written proposal.

The proposal may contain all or some of these elements:

- The log line: this is a summary of the story in one or two lines and is the hook to attract interest in the script
- The story outline and context of the story
- Biographies/CVs of the writer, producer and director
- Cast suggestion: a producer may indicate a famous actor is interested in the script/part. This can make the project more viable and easier to sell or distribute
- Indicative budget and top sheet: a preliminary financial summary.

Drafts

Very few dramas will shoot the first draft of a script. Often, the script will go through several rewrites before filming begins.

Script
The script is developed from the treatment (*see* page 107).
Copyright: Momoko Abe

The team > **Development** > Pre-production

Script format

Industry formats and standards exist that will help the producer draft and present a script. There are various layouts used for writing films, TV shows and plays.

Final Draft AV is designed for writing scripts with a two-column format – video column and audio column. It is suited to documentary and commercial production. For more information, visit: www.finaldraft.com.

A drama script layout follows the basic layout opposite. A rule of thumb is that one page = one minute of screen time.

A Scene description
B Interior (indoors) or Exterior (outdoors)
C Scene direction
D Character name
E Scene number
F Point size 12, Courier font
G Wide shot – only include camera direction if absolutely necessary
H Dialogue

Final Draft
Final Draft is a useful scriptwriting software for writing and formatting a script to follow the standard layout conventions. (www.finaldraft.com)

Smart Type
Remembers and automatically fills in character names, scene headings, transitions, locations and more. All you need to do is type the first few letters and Smart Type will instantly type in the rest.

Revisions
Easily handles multiple revisions, setting off revised text with a customizable color and margin marks.

Pagination
Automatically formats and paginates to industry standards.

Panels
Organizing and developing your story has never been easier. The Panels System allows you to view your script, its outline and index cards at the same time.

The Index Cards can contain both scene and summary notes for a particular scene. The Outline Panel provides quick and easy navigation through the script.

```
            TITLE SEQUENCE.
E
A   1       INT: HALLWAY: A PARTY.                              1
D
            Pressed close, a man and GIRL 1 laugh. STEVE rudely pushes
            between them, moving on through a couple more party goers.

B   2       INT: C/U TABLE.                                     2
F
            A glass of wine is overfilled.

    1a      INT: HALLWAY: PARTY.                                1a

            STEVE continues to walk towards camera, he's angry but
            contained. He knocks into someone spilling their drink. He
            doesn't care.

    3       INT: C/U BOTTLES IN PLASTIC TUB.                    3

            A bottle of beer is pulled from a tub filled with ice.

    1b      INT: HALLWAY: PARTY.                                1b

C           STEVE walks up to the kitchen door, which is shut. He
            stops, calms himself, turns the handle and opens the door.

                                                    TITLE:
                                                    SUGAR
G
    4       INT: KITCHEN: EARLY EVENING. LOCKED OFF CAMERA W/S. 4
            THE ACTION MOVES IN AND OUT OF FRAME. CAMERA DOES
            NOT MOVE AND THERE ARE NO C/A'S.

            PETE, KRIS and MICKY are sitting drinking around the     *
            table. We hear the party, the people and the music
            in the house off camera. STEVE barges through the
            kitchen door and looks straight at MICKY.
                                                                     *

            He pulls up a chair and sits down, his arms crossed.

                              PETE
                          (laughing)
H                       No...I don't believe that.

                              MICKY                                  *
                      it's true...it happened in Tokyo               *
                      in the 1920's - there was a                    *
                      terrible fire in a factory...                  *
```

Sugar
This page from the 10-minute short,
Sugar, is set in the conventional
layout for a drama script.

Once the script has been approved or 'green lit', the project will go into pre-production. This is the period when much of the planning and preparation needed to make the film happens. There will be regular production meetings with members of the team and crew, such as the director, art director and script supervisor, at various stages of the pre-production period. The producer will also be hiring the crew, securing locations and contracting the actors.

Meanwhile, the director will be dealing with other elements of pre-production, such as scouting locations, carrying out rehearsals with actors, having walk-throughs with the various department heads and creating storyboards.

Because a drama producer has to deal with and keep track of so many different elements he or she must be extremely organised.

/ Budget

Early on a preliminary budget will have been produced in order to get the project off the ground. Once the producer has an idea of how long the project is going to take and the director has indicated what he or she wants, the producer is in a good position to draw up a realistic working budget.

The producer will need to cost every creative intention of the director and assess whether these can be accommodated within the budget. The producer must continually assess the needs of the project and be able to use the money that is available in as creative a way as possible. An integral part of this process is the script breakdown which is covered later in this chapter.

The drama budget may have to cover the following elements:

Above-the-line costs

These are costs that are earmarked for the creative part of the production. This is usually a flat fee and includes:

- Producer/producers
- Director
- Writer
- Cast
- Script or story rights.

Below-the-line costs

These cover all the technical costs to make the film. Below-the-line costs have to be worked out on a weekly or daily basis.

Paying people

On a no-budget or a student short, the bottom line is to at least pay capped expenses, provide food during the shoot and a copy of the finished film. To avoid any misunderstanding, the producer needs to negotiate with cast and crew early on, to make sure everyone involved is clear about what is expected before filming starts.

If you are lucky enough to have some funding, you will need to consider how much you can pay people within the limitations of your budget. A good starting point is to consider paying at least a fair minimum wage.

The reality is that producing films on a limited budget means that every situation is different and the producer will need to negotiate within the context of the production finance. In some cases the producer will need to be fully up to speed on employment law and how it applies to the project. For more infomation, see: www.bectu.org.uk, www.equity.org.uk and www.fia-actors.com.

Page 6

Acct No	Description	Amount	Units	X	Curr	Rate	Subtotal	Total
93520	OTHER LABOR							0
93521	LOCAL HIRE LABOR							0
93531	COSTUME HOUSE LABOR							0
93532	MANUFACTURE & ALTERATIONS							0
93533	FACILITIES							0
93534	CLEANING & DYEING							0
93551	EXPENDABLES							0
93553	PURCHASES - WRDB & FABRIC							0
93554	PURCHASES - OTHER ASSETS							0
93555	RENTALS - WARDROBE							0
93556	RENTALS - EQUIPMENT							0
93561	LOSS, DAMAGE & REPAIRS							0
93563	BOX RENTALS							0
93565	CAR ALLOWANCE							0
93570	OTHER CHARGES							0
Account Total for 935								**0**
937 MAKE-UP AND HAIR								
93701	MAKE-UP ARTIST							0
93702	ADDITIONAL MAKE-UP							0
93703	BODY MAKE-UP							0
93705	HAIRSTYLIST							0
93706	ADDITIONAL HAIRSTYLIST							0
93731	HAIRPIECES & APPLIANCES							0
93751	EXPENDABLES							0
93753	PURCHASES							0
93755	RENTALS							0
93763	BOX RENTALS							0
93770	OTHER CHARGES							0
Account Total for 937								**0**
939 SPECIAL EFFECTS								
93901	EFFECTS KEYPERSON							0
93902	EFFECTS PEOPLE							0
93920	OTHER LABOR							0
93924	RIGGING							0
93925	STRIKING							0
93951	EXPENDABLES							0
93953	PURCHASES							0
93955	RENTALS							0
93961	LOSS, DAMAGE & REPAIRS							0
93963	BOX RENTAL							0
93965	CAR / TRUCK ALLOWANCE							0
93970	OTHER CHARGES							0
Account Total for 939								**0**
941 SET OPERATIONS								
94101	STANDBY PAINTER							0
94102	STANDBY LABOR - STUDIO							0
94103	CRAFT SERVICE PERSON							0
94104	FIRST AID PERSON							0

The Entertainment Partners Services Group, EP Budgeting

Budget

The costs attached to the production should be worked out on a weekly or daily basis. At the top of each page will be the following headings:
Amount (days or weeks)
Units (how many days or weeks is the equipment or person hired for?)
Rate (the daily or weekly cost of the person or equipment hire).

Development > Pre-production > Production/principal photography

/ Student drama

Producing a short drama with little money, limited access to equipment and complex availability of cast and crew is the world of the student producer.

The following identifies the key areas a student producer will need to consider when budgeting for a production:

- Camera, sound and lighting equipment
- Cast and crew
- Post-production and any transfers
- Tapes/stock
- Art department
- Catering/food
- Location fees
- Transport and travel
- Hiring of any specialist equipment that cannot be provided by the college or university
- Additional insurance
- Office or running costs, such as copying, telephone and postage
- Publicity costs – this will cover DVD copies, film-festival entry fees and publicity packs.

A drama budget can be complex. When a producer is costing different elements there may be various issues which arise that can affect the budget and/or schedule.

/ Technical equipment

There is a vast range of equipment available to the production team and choices will need to be made. Camera hire companies provide these services. The use of specialist equipment will invariably mean extra crew and additional expense. You will need to check with the hire company what insurance cover will be needed. For further information, see: www.theknowledgeonline.com.

/ Location

Location choice can affect the schedule as well as the budget. So remember, appropriate access will need to be negotiated and confirmed. Shooting in the winter when it's cold, wet and daylight hours are restricted may mean less exterior shooting time and may also mean that the crew need more food and drink. Other issues to consider include access to adequate facilities, such as electricity, as well as the need to consider health and safety.

/ Cast

The cast will need to be kept warm and dry when not filming on-set. The bigger the cast, the more time and expense required to prepare, rehearse and move equipment. The more people involved in a scene, the more time it will take to shoot.

Working with children brings its own set of issues as discussed in Chapter Two: The Basics.

video & sound

- **HD Cameras**
- **SD Cameras**
- **Accessories**
- **Lenses**
- **Monitors**
- **VTR & Playback**
- **Sound**

video & sound

grip & lighting

editing & transport

Equipment hire
Camera hire companies will be able to supply the equipment and services required for a shoot.

Factors that can influence the budget and the schedule:

- · Set building
- · Set dressing
- · Art direction
- · Special effects, such as wind/rain machines
- · Stunts
- · Choreography
- · Costumes
- · Special props

HD video

Daily rate

HDCAM Sony HDW-F900
Cine Alta HDCAM camera 1920 x 1080 resolution capable of shooting at 24P, 25P or 30P progressive scan modes, 50i or 60i interlaced 12 bit processing 500

DVCPRO HD Panasonic AJ-HDC27 Varicam
High Definition camera 24P/25P DVCPro HD with variable shutter speed up to 60 frames per second 475

HDCAM Sony HDW-750P
HDCAM High Definition digital camera with 25P progressive scan or 50i interlaced modes 385

DVCPRO HD PANASONIC AJ-HDX400
Records in 1080/25p & 1080/50i, true 16:9,with a 2/3″ 3-CCD chip with built-in SD down-converter 350

HDV Sony Z1E
High Definition camera with near Digital Betacam quality shoots in, DVCAM and HDV (PAL and NTSC) The HDV captures in true widescreen. 110

HDV Sony A1E
Ultra compact camera with 1080 HDV resolution, 16:9, night vision and firewire 80

Development > **Pre-production** > Production/principal photography

Script breakdown

As well as preparing and managing the budget, the producer will be overseeing the script breakdown. A script breakdown is an analysis of all the components involved in all the scenes in the script. It will list locations, props, actors, extras, costumes and any special effects. This enables the producer to cost every item in the film and to work out the most effective shooting schedule.

The breakdown can be used to organise the location shoots. Identifying individual scenes for specific locations will help to estimate the time needed to complete the production and to create a shooting schedule.

Most films shoot out of script order as it is cost- and time-effective to group and shoot all the scenes that take place in a specific location. This is obviously preferable to shooting one scene in a location, and then having to move the crew, cast and equipment to another location, only to return to the original location for the next scene within the same day.

Obviously a feature-length film shot over several weeks or months will have a far more complicated breakdown and production boards than a short film.

Casting and finding actors

Finding the right actors for the project is crucial to the film and can often be integral to the funding and financiers. For a fee, professional drama producers bring on board casting directors who are knowledgeable about up-and-coming actors and have good relationships with agents. The producer will need to organise and manage this process and often provides creative support to the director throughout the decision-making process.

As a producer you will have to organise advertising the roles, setting up casting calls, auditions and any call backs. The starting point is to draw up an advert, which will need to include the following:

- **Information about the role – including age and any key physical characteristics**
- **A synopsis of the story, dates/location for the shoot, format and running length.**
- **Full contact details for the production team or company**
- **Audition dates and details**
- **Any payment details if relevant.**

Places to find actors

Places for find actors include:

- **www.shootingpeople.com**
- **www.talentcircle.com**
- **www.pcrnewsletter.com**

Remember, while some have open access, others will require a membership fee.

Script Breakdown Sheet

Date_____

Production Company

Production Title/No

Breakdown Page No

Scene No

Scene Name

Int/Ext: *Interior or Exterior.*

Description: *One line of description of what happens in the scene.*

Day/Night:
As indicated on the script.

Page Count: *Pages are divided into '⅛ths' or eight sections. This is NOT the page number the score is on.*

Cast: *Anyone with a speaking role.*	Stunts: *A fight or fall, for example. These should be performed by trained experts.*	Extras: *Non-speaking members of the cast who fill the scene.*
	Extras/Silent Bits	
Special Effects: *Fireworks or firearms, for example.*	Props: *Any props handled by the character, as indicated in the script.*	Vehicles/Animals: *For example, a car that a character drives in a shot.*
Wardrobe: *Special costumes or wardrobe details.*	Make-up/Hair: *Any special make-up, such as wounds or materials to age character.*	Sound Effects/Music

Script breakdown sheet
The script breakdown provides details of all of the components involved in each scene of the script.

/ Shooting schedule

Another key part of planning a shoot is the preparation of the shooting schedule. This outlines the order that the scenes in the script are going to be shot, maximising time, money and resources. Once the script has been broken down and transferred to the production board, the schedule can be created. The producer's starting point is to build the schedule around key or fixed dates. These might be:

- Availability of the key actors (they may have other filming commitments that they are already contracted to)
- Availability of key locations
- Any night shoots
- Union regulations on length of days/night shoots
- Any special effects
- Any stunts.

Remember, as mentioned earlier, when working out a shooting schedule it is a good idea to identify the locations and then group all the scenes that take place in the location together. Plan to shoot exteriors first then move inside to interiors.

Work out the length of each working day. A 10-hour day with breaks is an average shooting day.

Try to work out what can be shot in a day. Aim to shoot around two pages per day. However, half a page of complicated action may take a day to shoot in itself. In contrast, a dialogue scene between two characters sitting at a table will tend to take less time to shoot. The more complicated the scene, the longer it will take to rehearse, set up and shoot.

It is possible to use scheduling and budgeting software that links into Final Draft. For more information, see www.entertainmentpartners.com.

Professional tips

// Producer pre-production checklist:
- Organise crew and contracts
- Set up an insurance package
- Set up auditions and rehearsals
- Negotiate actors' contracts
- Research post-production facilities
- Research and finalise locations.
- Ensure licences and contracts are signed and relevant security arrangements are in place
- Organise transportation
- Negotiate cast contracts
- Oversee and distribute relevant paperwork – eg call sheets
- Organise stock
- Organise catering
- Oversee risk assessments

Starting point/tips

Points to consider when creating a shooting schedule:
- Every time the camera is moved within a scene the lighting may need to be changed
- Some film equipment is very heavy to transport
- Lighting a large space is more complex. Apart from needing more lights you will need more time for crew to set up and to clear up
- Start with an easy day. This is especially beneficial for your actors
- Be realistic about what you can achieve in a day

END POS
Scene 2

Scene 16 AFTER FOOD
~~has~~ been put on Table

Sc. 2

Scene 3

Continuity stills
Continuity stills are used in order
to record how a scene looks at the
beginning and end of a scene. These
can then be referred to if it needs to
be re-shot at a later date.

/ Risk assessment

Health and safety is paramount, as is the producer's responsibility to ensure all relevant forms are filled in and signed off for all locations. Chapter Two: The Basics explores this area in greater detail.

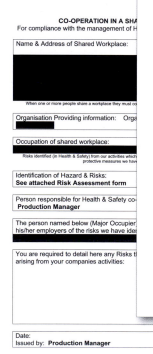

Whilst every precaution has been taken by ▮▮▮▮▮▮▮ and our contractors to ensure that all camera positions etc are safe, you are reminded that, under the Health & Safety At Work Act, section 7, it is a general duty of all employees to take reasonable care for the Health & Safety of themselves and of others who may be affected by their acts or omissions. A list of identified hazards is attached and all staff should observe precautions that have been taken to minimise them. Please report any hazard to the ▮▮▮▮▮▮ Production Manager or the OB Unit Manager of the appointed facilities company. This is of particular importance to anyone who is self employed.

HAZARD ASSESSMENT CHECK LIST

Highlight if applicable.

1. Blocked or Restricted Access / Egress
2. Flying (Aircraft / Microlights / Balloons / Parachutes)
3. Animals
4. **Public / Crowds** / Violence
5. Hazardous Substances (Chemical / Poisons / Drugs / Micro-organisms)
6. Compressed Gas / Cryogenics
7. Confined Spaces (Mines / Sewers / Caves / Fuel Tanks / Excavations)
8. Derelict Buildings / Asbestos
9. Diving Operations
10. **Electricity** or Gas (inc. LPG Heaters)
11. Special Visual Effects (Pyrotechnics / Explosives / Mechanical / Rain / Snow / Smoke)
12. Fire / Flammable Materials / Scalds / Burns
13. Heat / Cold / Extreme Weather
14. Special Needs (Inexperienced / Child / Elderly / Disabled)
15. Lasers / Stroboscopic effects
16. **Machinery (Industrial cranes / hoists)**
17. **Noise**
18. **High sound levels**
19. Physical / Abnormal stress
20. Radiation
21. **Scaffolds / Rostra**
22. Stunts / Dangerous activities
23. **Vehicles**
24. Water / Proximity to water
25. Weapons
26. **Working at Heights**
27. Night Operations
28. **Other:** *Specify*

Check list completed by:
Date completed:

CO-OPERATION IN A SHA▮▮▮
For compliance with the management of H▮▮▮

Name & Address of Shared Workplace:

▮▮▮▮▮▮▮▮▮▮▮▮

When one or more people share a workplace they must co▮▮

Organisation Providing information: Orga▮

▮▮▮▮▮▮▮▮▮▮▮▮

Occupation of shared workplace:

▮▮▮▮▮▮▮▮▮▮▮▮
Risks identified (in Health & Safety) from our activities which ▮▮▮ protective measures we hav▮

Identification of Hazard & Risks:
See attached Risk Assessment form

Person responsible for Health & Safety co-▮
Production Manager

The person named below (Major Occupier)▮
his/her employers of the risks we have ide▮
▮▮▮▮▮▮▮▮▮▮▮▮

You are required to detail here any Risks t▮
arising from your companies activities:

Date:
Issued by: **Production Manager**

Risk assessment preparation
As part of the risk assessment preparation, the producer will need to list all possible hazards that may present themselves during a shoot.

RISK ASSESSMENT

Venue:

Event:

Date:

Hazard	Hazard Effect	HE	P	R	Minimise Risk by	Residual Risk
	HE x Probability + Risk					
Trip hazard	Trailing cables	M	M	M	Fly cables were ever possible or use cable ducts, cables at floor, crossing public access points should be matted	LOW
Working at Heights	Items or persons falling	H	H	H	Harness used for persons working at height. Drop zone in place during rig and de-rig of equipment.	LOW
Scaffolds / Rostra	Items or persons falling	H	H	H	Scaffolds access to authorised persons only. Drop zone used during rig/de-rig. Toe boards fitted to scaffold or rostra.	LOW
Vehicles	Injury from collision with moving vehicles	M	M	M	Persons to be aware of vehicle movements during period on site	LOW
Hoists	Persons or equipment falling from basket of hoist during rig / de-rig or operation.	H	H	H	Persons to wear approved harness when working in basket. Access by approved personnel only. Safety chains to be used on equipment where required. Drop zone employed during rig / de-rig.	LOW
Crowds	Injury due to crush, in the case of emergency evacuation	M	M	M	Staff to be aware of all emergency exits available to them	LOW
Electricity	Electric shock	M	M	M	Generators to be managed and supplied by competent contractor. All electrical equipment to be tested and meet appropriate local standards.	LOW
High noise levels	Temporary deafness	M	M	M	All staff to use suitable ear defenders or ear plugs in areas of high noise.	LOW

Assessment undertaken by: Production Manager

Date undertaken:

Risk assessment form
When all the assessing of risks has been completed, a risk assessment form is compiled, which identifies all potential risks and the measures put in place to prevent them.

This is an intense and exhausting period when the production starts and the pressure is exacting. During this stage of production there will be little time to solve problems. Many issues and problems should have been anticipated during pre-production, allowing for backup plans to be put into place. Where possible some flexibility should always be built into the production schedule.

/ The role of the producer during production

During filming the producer must ensure everyone is aware of what has to be achieved during the shooting day. The producer does not normally have a role on-set. The director literally calls the shots and the assistant director will keep the film unit on course. The producer will only get involved if the filming is starting to seriously overrun the schedule or if difficult situations need troubleshooting.

The basic role of the producer during production is to:

- Keep spirits and morale high
- Keep an eye on the budget
- Keep to the shooting schedule
- Ensure all locations, transport and catering is confirmed
- Ensure safety on-set
- Oversee equipment packages. Ensure relevant insurance documentation will be on hand. Return any unused equipment to the hire company
- Ensure the set or location is cleared and put back into its original condition.
- Make sure all rushes are clearly labelled and stored securely.

/ Weather

When shooting exteriors, a change in the weather can have a catastrophic impact on the shooting schedule and the budget. The standard procedure is to shoot all exteriors at a location first, then move inside for any interior scenes. Where possible plan to have an alternative interior location in case it rains.

/ Logistics

Check, check and check again that all the arrangements are made. Parking, catering and equipment need to be planned before the day of the shoot. Inexperienced crews working under pressure can present a potential health and safety issue. The producer should keep a close eye at all times and always plan adequate rest and food breaks.

/ Looking after actors and crew

The producer should not get involved with directing the actors. However, the producer should ensure that morale is kept high.

Is it clear that the production is providing catering? Some no- or low-budget productions will ask cast and crew to provide their own food. However limited the budget, the producer should endeavour to feed and water everyone. It shows respect for a hard-working cast and crew, as well as displaying a professional attitude to the project.

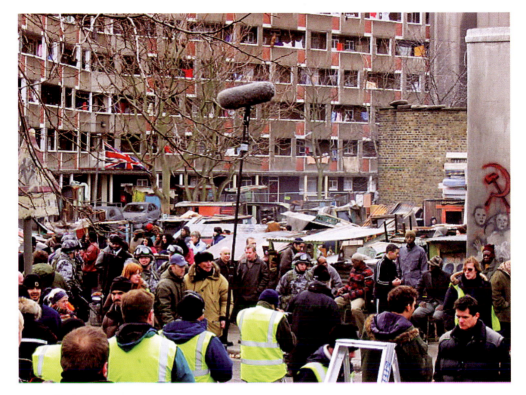

Logistics
Although the producer does not get involved in directing actors, it is his or her responsibility to manage the overall organisation and logistics of crew and actors.
Courtesy of The Film Office

Starting point/tips

- Ensure the shooting day is keeping to the schedule and avoid wasting time and energy dwelling on a mistake or an issue
- The producer's job is to sort the problem out, move on and keep the crew and actors motivated
- Anticipate any problems – if something can go wrong assume it will so always have a plan B
- Complicated scenes will need more time allocated to shooting them, such as tracking shots or crowd scenes
- Make sure everyone knows their responsibilities and ultimately who is in charge on-set

Once the shoot is over the editing and shaping of the story begins. At this stage the producer has to ensure that the project is keeping to schedule and budget. This should become easier as the project enters the editing stage as there are simply fewer people involved.

Editing is always a highly creative stage in the production process and student film-makers can often overlook the importance of attention to detail. The editor and director should be obsessive when it comes to both sound and vision. The producer should allocate adequate time for the edit and dedicate sufficient time to research, locate and manage all aspects of post-production sound. The editor will invariably need to watch all the rushes, as they need to be familiar with the material before editing starts.

The basic stages of editing are:

- Logging and digitising
- First assembly (getting the basic structure of the film in order)
- Rough cut
- First cut
- Fine cut
- Final cut.

With projects shot on digital formats most of the sound editing will take place in the edit. Once the picture is cut the next stage is to go to a sound studio for track laying before for the final mix.

/ The role of the producer during post-production

As with documentary production the producer will tend not to be directly involved in the early stage of the edit. This is the domain of the director and editor who will be working closely together. The producer will be involved at some stage of the edit, but his or her primary role is to keep the project on track.

The basic role of the producer during post-production is to:

- Keep an eye on the schedule and the budget
- Manage the marketing and distribution of the finished documentary, including organising copies of the final film
- Ensure all clearances, especially for any music tracks
- Organise a date for the sound mix
- Set a date for final delivery.

/ Marketing and distribution

Ensuring the film is seen by as many people as possible is vital for the film-maker. Without the backing of a distributor or an organisation, the cash-strapped producer will have to find effective ways to publicise the film.

Cast and crew screening are a useful way to finish off a successful production and say thank you to all involved. The inventive producer looking to fund the next film may also try to set up a screening for industry people and financiers. Film festivals and the Internet open up further screening, distribution and marketing possibilities.

For further information on exhibition and distribution, see Chapter Two: The Basics, and the following websites: www.lux.org.uk, www.eurofest.org and www.bfi.org.uk.

Starting point/tips

Inexperienced film-makers often underestimate the amount of planning and forward thinking needed during the edit. Some golden rules to follow are:

- Ensure that all tapes are labelled and kept securely in one place and that they are accessible to relevant members of the production team
- Check and check again that the final edit is in sync and the sound levels are correct
- Research music in advance
- Log rushes clearly
- Allow plenty of time for track laying and sound design

/ **Amanda Jenks**

Before entering the world of drama production, Amanda Jenks worked extensively as a producer and series producer on major factual/documentary series filmed in the USA and UK for Channel 4, the BBC and other major broadcasters. As a drama producer she nurtures award-winning projects from development through to screening.

Can you tell me who you are and what you do?

I would describe myself as a creative producer. I tend to create projects from the initial idea, or a writer will come to me with an initial idea. I will either work with the writer or attach a writer to an idea of mine and then see the project through from the initial treatment, pitching it to the channel, commissioning the script, hiring the crew, right through to post-production and delivery.

Tell me about the relationship between the writer and producer.

I think a lot of the job as producer really is to help people realise not only what I want but also their own voices. The relationship between the producer and the writer is project specific because no two people are ever the same. My job is about creating a space and a dialogue with the writer in which they can do their best work. Different people need different things from me. Some people need an awful lot of meetings and call me up in the middle of the night wanting to discuss every single scene and nuance of the script. Other people really need to bury themselves away, so I make sure that everyone else leaves them alone during their writing period.

Can you talk about developing ideas from true stories?

True stories obviously bring an enormous responsibility as you are dealing with real people, so in order to tell a story you have to be true to the facts. Even though you are telling a story you have to make sure that you are being fair to the characters and the people involved. I, for instance, would never make a story without getting people involved and on board. I absolutely seek permissions; you have to make sure that you legally tie [up] that relationship with them, [in the form of] some sort of permission type contract, which again is project specific. I think that what people tend to forget is there is an enormous duty of care after a piece is finished and has been aired. You certainly have to make sure that you carry on that relationship in some shape or form afterwards, and that you make the ones portrayed in the drama have all the support and help to get through.

What makes a great pitch?

The best pitch is always something that people get immediately; it is always something that doesn't need a lot of explanation. Having said that, there are some things that are more difficult to grasp. For me I am quite lucky as I do get to sit down with the commissioning editors face to face. But having said that, we increasingly have to send our pitches on paper via e-commissioning and I do think that tone is one of the hardest things to achieve on a piece of paper. If it is funny then the pitch has to be amusing; if it is a thriller the pitch has to have suspense in it. The pitch pages are difficult. I think it is one of the hardest things about the whole process.

Producing drama

'MY JOB IS ABOUT CREATING A SPACE AND A DIALOGUE WITH THE WRITER IN WHICH THEY CAN DO THEIR BEST WORK.'

For the novice producer what is a pitch page?

We are asked for different things. Sometimes you can send a paragraph and if they like it enough it can go into a treatment or outline, which can be the difference between four to six pages and 18 pages depending on what it is that you are pitching. There is a big difference between a single and a mini-series. For a series, if they like the paragraph you have written and they like the writer they will ask you to come up with a series bible and a first episode. A series bible is how the whole thing is going to play out, what story arcs are across the series, what happens in each episode, how the characters are going to develop, the format of it. But if it is a single, I will often get a response on a couple of lines and I will work on no more than one side of A4 with a writer, written in the tone of the piece. The pitch is an indication of what they will get if they give you the money; it tries to excite them in some shape or form. So you give enough away in a pitch page, for people to want more.

Who else do you work with?

If we are to go into production, the first person I would look to work with, apart from the writer, is the director. I usually employ the director knowing the sort of look and vision they will want. Then there is the delivery side – the line producers and the accountants. As the producer I not only have to achieve the creative vision but also I have to worry about things like budgets and deliveries, how things are going to be done and how we are going to get the most money on the screen.

Could you describe a typical week?

I rarely have a typical day or a typical week. Right now I am just about to go on to prep on a big show, so I have been interviewing Heads of Department the last two days. Another channel is interested in an initial idea for something else, so I have had to go to a meeting in-between. I am also getting a second draft down for another piece with another writer. You have to be a good multi-skiller and juggler as a producer, because in the course of any day you can be dealing with many different people and projects, which require you to think quickly both practically and creatively.

Post-production > Case Study: The creative producer

PRODUCING MAGAZINE SHOWS

Breakfast TV, game shows, sitcoms, talk shows and reality TV.

Today's TV schedules are filled with a wide and varied range of television programme formats. Types of programming which have become the bedrock of broadcast production. Tried and tested ways of successfully delivering content that is not only relatively cost efficient to produce, but can attract sponsorship or advertising revenue.

The potential revenue for re-commissioned series formats is huge, and creating a successful TV format can be a highly lucrative way for a production company to grow. The TV industry is hungry for new, fresh ideas and speciality formats. These genres are in a continuous state of flux and change.

Large audience ratings for a domestic hit TV show can have potential for substantial international sales. The rights to the format can be licensed to other broadcasters. For example, versions of the reality show Big Brother format are broadcast across the world with especially made versions showing in the lucrative territories of Europe, North America and the Pacific.

This chapter will look broadly at types of programme formats and industry procedures. It will consider the basic skills needed to successfully manage a magazine show, but will not deal with the highly specialised and technical production skills necessary in live TV and gallery production. That's for another book.

Programme formats
There is now a wide and varied range of television programme formats available to the viewer.

CNN Headline News

Synopsis

CNN (Cable News Network) is a major US news cable television network. CNN was the first station to provide 24-hour news coverage.

Various producers

Due to the fast-paced nature of news reporting, CNN Headline News has many producers who oversee teams of people working on a rolling schedule. This allows them to work quickly and to respond to news stories.

Before looking in more detail at magazine show production it is important we first consider the basic range of programme formats currently being offered by production companies and broadcasters. Formats offer a range of packaged content from hard news to reality shows. These types of programmes tend to follow conventions both in structure and presentation of the content.

New formats tend to be tested in the form of a pilot programme. This will establish a clear indication of style, content and identify possible participants. The pilot may then be broadcast to allow the broadcaster to receive detailed feedback. This will identify whether an audience exists for the project without the need for investing large sums of money.

The different types of TV format programmes include:

Chat shows

These tend to be presented by a well-known TV personality and are usually set in a studio-based location. Quiz show and panel discussion shows are given a similar treatment.

Sports programmes

These can be delivered in multiple formats – from live games to magazine shows.

Music programmes

This is a continually evolving format taking in live performance, chat, music video and pre-recorded video feature material.

Game shows

These are programmes such as *Britain's Got Talent*, *The Weakest Link*, *Wheel of Fortune* and *Jeopardy!*

Reality TV shows

These include shows such as *Big Brother*, which is produced and broadcast worldwide, and *Age of Love*.

News and current affairs

These are studio-based programmes generally presented by one or two newscasters. They contain pre-recorded stories (VT), live interviews in a studio or on screen and live/recorded transmission from reporters on location. News production is fast paced and highly pressurised. The producers obviously needs to respond quickly to changing events.

For more information, visit: www.ukgameshows.com, www.broadcastnow.co.uk and www.tv.cream.org.

Big Brother 2007
An example of a reality TV
programme format with a
global audience.

Magazine shows are constructed from features linked by in-vision presenters, or out-of-vision voice-over. Similar in concept to the printed magazine, they offer a range of items packaged within a single programme.

This type of programme may contain a range of content including news, documentary, drama, interviews, graphics and archive footage.

They often involve several members of a production team working on various items at any given time to tight budgets and quick turnarounds. In order to understand the roles involved in this type of production, a typical working week in the life of a magazine programme will be considered later in the chapter.

Preparing for a magazine show
Magazine shows often involve
several members of the production
team working closely together
on tight budgets and to tight
schedules. There is a lot of work
involved, and it can be very stressful
at times.

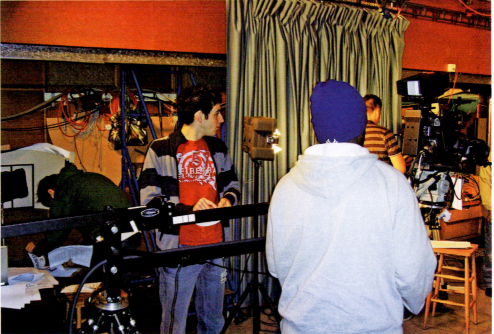

Magazine programme production can be highly pressurised. It relies on all members of the team working closely together against deadlines and budget constraints. The producer needs to be cool under the pressures of production and must keep the team on course. It is his or her job to organise the team, decide programme structure and ensure that all the members of the team are delivering on their allocated tasks. With fixed transmission times the programme has to be made come rain or shine.

Alongside assuming editorial responsibility, the producer also needs to ensure that the production schedule stays on course. Liaising closely with the production manager, crews need to be hired, editors and edit suites assigned and satellite links or dubbing booked.

All the ongoing issues discussed in Chapter Two: The Basics, such as copyright clearances, permissions and associated ethical issues are of course an integral part of the mix.

EXECUTIVE PRODUCER

A PRODUCER OR PRODUCERS

Depending on the nature of the programme. For instance, a daily news programme will require several producers working on a rota, each dedicated to particular days of production.

ASSISTANT PRODUCERS (APs)

Most programmes will have a team of APs who will produce individual edited stories or features.

PA

Works as part of the team to coordinate scripts, meetings and ad hoc production business.

Filming
The resulting shots from the day's
filming will be cut by the editors,
who work closely with the producer
and APs.

PRODUCTION MANAGER

Works closely with the
producers overseeing
budgets, schedules etc.

RESEARCHERS

There may be several
researchers working on
a programme. They are
assigned the role of
identifying possible leads
or stories and collating
background information.

EDITORS

There may be multiple
editors working with the
assistant producers and
the producer, editing
material on a daily basis.

The primary responsibilities of the producer are to keep the project to the production schedule and on budget, and ensure that the overall mood, tone and visual style of the programming is maintained for reasons of editorial consistency.

/ **The production meeting**

The key event at the beginning of a production week is the production meeting. These meetings are a vital part of the production process. They allow problems to be aired, the sharing of information to take place and enable forward planning. It is at this stage that tasks are agreed and allocated. Useful for team building and cohesion, these meetings also ensure that content, editorial style and presentation is debated and evolved.

The production board
Through the use of a production board, all of the day-to-day programme details can be seen at a glance.

/ The production whiteboard

This is a useful way to display elements of the production schedule so that they may be understood at a glance. It can show programme running orders, shoot days, edit days and how these differing elements mesh together. It can also give an indication of required running lengths and deadlines. Essentially, all production staff can see what's coming and what's planned.

/ Research

Ideas for the features will usually be pitched by the APs or researchers. These will be discussed in the production meeting and the go ahead given by the producer for further development and research.

Depending on the subject matter there will be a variety of strategies adopted to identify and contact contributors. This can involve researching news and current affairs stories, placing ads in the papers, or perhaps using stringers or production team contacts in the field. The longer a programme is in production, the longer the contact list.

/ Budget

Magazine programming will have an overall budget, which will need to be spent over a number of programmes, whether it is a six-part series or a weekly programme that airs every week of the year.

The producer and the production manager will need to work out a feasible working budget per programme. As in the case of drama or documentary production, the budget will need to cover the differing stages of production. Additionally, costings for talent, whether it be an in-vision presenter or a voice-over, need to be included. Also graphics and technical costs, such as satellite feeds, will all need to be allocated funding.

/ Presenter/talent

Magazine programmes usually require presenters relevant to the type of programme being produced. For example, a well-known sporting personality or journalist will generally feature on a football programme. The producer will therefore need to identify, very early on in the programme's development, who needs to be attached to the project. This may involve negotiating with agents or organising casting sessions to find a new face.

Professional tips

The producer's responsibilities include:
· Editorial overview of the content and presentation of the programming
· Liaising with the production manager to ensure that the budget is staying on track

· Creative decision making about the visual style and graphic look of the programmes (essentially the blueprint for how the show will look, ensuring consistency over the features)

A feature of this type of programme making is that, once the project is up and running, it is in a continual production cycle of pre-production, production and post-production. The producer has to make sure all the elements are running smoothly, has to keep an eye on the programme coming up, as well as carrying out ongoing research. There will also be a pool of pre-cut material ready to be slotted into a programme in case anticipated projects fall through.

/ Shooting the features

With editorial guidance coming from the producer, the key people at this stage are the assistant producers (APs) and researchers. They will have researched the story, found the contributors and identified suitable filming locations before shooting the feature. The producer will be keen to maximise cost savings, encouraging the APs to shoot material for use in other stories planned for subsequent weeks. This helps establish a pool of material ready for cutting for future programmes at short notice.

/ Presenter

The role of the in-vision presenter or voice-over is to give editorial cohesion to the programme and to provide links between the different features. This part of the production can take place in a sound studio, TV studio or on location, depending on the style of the programme. Scripts will need to have been written and edited by the producer prior to filming or sound recording with the presenter.

/ Graphics

The graphics element of a programme will include title and end credit sequences and stings. These will have been designed and prepared well in advance of the first ever transmission. Other graphics will be created on a weekly basis in response to programme content, such as straplines and pages with information. Often with music, graphics give the programme a strong visual identity and branding within the market place.

Running glossary

> · **Sting** a very short visual used between features or other items
> · **Straplines** also known as lower thirds, these provide information that is placed towards the bottom of the screen, usually to identify interviewees

Producing magazine shows

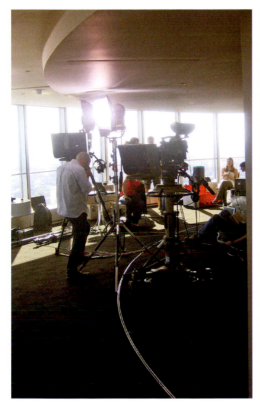

Studio shoot
There can be a large production team involved in the actual shooting of a show.

Autocue
The autocue is a computerised prompting system that allows the presenter to read the script while presenting into the camera.

Professional tips

The producer's responsibilities include:
· Deciding the running order of the programme
· Editorial control of the stories and how they are to be shot
· Drafting the graphics list

· Ongoing budget consideration, anticipating any over-spends and allocating funds to music and archive clearance
· Drafting the script
· Establishing running times
· Overseeing any archive and music clearance

In magazine programme making there are two stages of post-production.

Pre-cut features

This is the responsibility of the assistant producers who shoot the stories. As well as producing an outline paper edit (feature running order) of the feature and writing the script, they will have logged and overseen the digitising of the footage. They will sit with an editor and shape the material into the finished piece to an agreed running length for the final programme stitch.

The stitch

This is where the producer will bring all the different elements together including pre-cut features, titles kit and graphics, cutting them together to create the whole programme.

Voice-over (V/O)

After the programme is edited together the voice-over will be added.

Versioning – delivery and transmission

These stages of the programme's production are considered in more detail in the case study on the following pages.

Running glossary

> · **Stitch** the final edit when all of the elements are cut together to make the completed programme
> · **Pre-cut features** shot and edited short items ready for the stitch
> · **Titles kit** package of materials, such as titles, stings and backgrounds

The transmission suite clock
The transmission suite clock is vital when producing live shows.

This section will take a closer look at how a magazine programme is produced day-to-day. The following example is of a football show transmitted once a week, 52 weeks of the year. This demands an extremely well organised schedule of production in a highly pressurised and intense production environment.

/ **Background information**

The programme is distributed to 150 broadcasters globally.

Transmission or TX details

Transmission in the UK takes place via satellite every Monday at 7.30pm.

The running length (how long the programme is on screen) will vary. As there are multiple clients for the programme, different versions with alternative running times are produced, primarily to cater for broadcasters' differing commercial break times. The running times are as follows:

- International version 26.00 (twenty-six minutes)
- UK terrestrial 24.30 (twenty-four minutes and thirty seconds)
- UK satellite 23.30 (twenty-three minutes and thirty seconds)
- Mobile clips 02.00 (two-minute edit with editorialised commentary for international distribution).

/ **The production team**

- Executive producer
- Producer
- Production manager
- PA
- Four assistant producers
- One researcher
- Editors (the editors have to cut five features during the week ready for the final programme edit).

Final programme edit

All elements, including the five features, graphics and any other material, is edited or 'stitched' into the final programme. In addition to this, short edited packages are produced for mobile telephone clips.

Studio shoot
Working on a magazine programme
often involves a large crew who work
as a tightly-knit team.

The running order

The running order of a weekly sports magazine programme is as follows:

A

D

B

E

C

F

G

J

H

K

I

A The countdown clock counting down
 before the programme starts
B Opening title sequence
C First feature profiling a player
D A graphic indicating teams in a group
E Sting
F Feature on Argentina
G Indicates what is coming up
 in the show
H Feature on kids football
I Feature on a manager
J Interview with player plus strapline
K End credits

Day 1 (10–12pm)

The production meeting takes place on the morning after the first transmission. All the production team get together to watch the latest programme. The team analyse each feature and discuss ways to improve the show.

They then move on to talk about the features being cut for the upcoming week, as well possible stories for programmes in the following weeks. Stories will be allocated to the assistant producers to plan, shoot and script. The researcher is assigned projects to research.

The production manager books crews, edit suites, talent and manages clearances and permissions.

Days 1 (12pm onwards) – Day 5

After the production meeting is over, the team go back to work making the following week's programme.

One feature a day will be cut by each individual assistant producer. For the rest of the week, they will be working on their scripts, finding appropriate music and archive material. They will also be researching, planning or shooting forthcoming stories.

Meanwhile, the producer will be script editing and in some cases rewriting the assistant producer's copy. Part of his or her job will be to sit in on the editing of the features with the AP to advise and ensure the editorial overview. He or she will also be re-calculating running times and writing the link elements of the script such as the menu, commercial breaks and next-week teases.

Planning ahead and keeping a tight control of the content of future programmes are absolutely vital for this type of production.

Professional tips

// **Producer's responsibilities**
It is the producer's responsibility to ensure that the following tasks are carried out:
- Correct versions of programmes are delivered to the client
- Transcripts of the finished programme are completed
- Clearances and music cue sheets are finalised
- The upcoming programme is on course
- Feedback is prepared for the next day's production meeting

Day 6

The programme edit or stitch day will take approximately 10 hours to complete. The team involved in this day will be the producer, editor and graphics operator.

The producer will work with the editor in a non-linear edit suite, such as Avid, building the programme from the pre-cut features, stings, titles and graphics. They will start with the first item on the running order, which is the Menu, and cut the programme accordingly from beginning to end using the running order as the programme template.

Once the programme has been stitched the graphics will then need to be added. These will be straplines/lower thirds and full-page statistics. This part of the edit can be time-consuming because of the amount of time it takes to render. The producer and the production manager will need to take this into account when budgeting and planning edit suite bookings.

By the end of the day the programme will be complete with graphics, ready for the final stage of the edit process – the recording of the voice-over. This will take place on the following day. The editor will also make sure that there is a 'clean' (without graphics) back-up copy of the edited programme. This version can be made available to international clients for rebranding in different languages. The editor will also need to transfer all of the audio on to an audio file ready for the next day's audio session.

Day 7

The programme has been edited, but it is still not complete. The next stage of the edit is to record the voice-over. The assistant producers will have written the script for the voice-over during the week, and these scripts will be edited by the producer. This is the final element in the production process.

The producer will direct the voice-over session using two presenter voices to give variety to the programme. The audio mixer will record the voices clean on to a separate audio track using the edited programme as a guide. The editor will then make sure that the final mix of voice, music and effects has a clean M and E audio track for the use of international clients.

The programme will have different running lengths depending on the client and the sound will be cut and pasted according to each version.

Day 7 (evening)

The final programme will be delivered by satellite as well a being copied (dubbed) on to tape to be couriered to clients across the world. Depending on the TV format eg NTSC, PAL or Secam, the tapes will need to be dubbed in the correct format. This is also known as 'versioning'.

Post-production > An example weekly magazine programme > Case study: The executive produceer

Chris Downham

Chris works for CSI Sports and has been responsible for an extensive range of sports programming for the English Football Association, FIFA, the Football League and UEFA, as well as long-running sports highlights and magazine shows. During his four years producing 'World Football' he was part of the team that made it into television's most widely watched soccer show, reaching 160 broadcasters and 200 countries worldwide.

What do you do?

I'm Head of Programming at an independent production company, which specialises in a range of sports content. My company represents a number of major sporting federations and commercial clients. The type of work we cover involves producing programming around live sporting events and making a variety of supplementary programming, such as promos, magazine programmes and previews, reviews and archive based programmes.

What do you mean by preview and review?

Previews are programmes that provide context to upcoming sporting events, reviews are obviously looking back at a sporting weekend.

What is a typical working week?

In the sporting world most events tend to take place at weekends. This means we are making supplementary programming to support these events during the week and then producing the live event on Saturday and Sunday. At the moment we are producing live studio programming around these events, which are broadcast on TV and the Internet.

What does that involve?

This involves a presenter and guests providing analysis of the events prior to the game and afterwards. We have a two-camera studio, a small gallery and a studio team of approximately ten people.

What do these people do?

There are two cameramen, a set designer, a director, producer, autocue operator, make-up artist, sound engineer, vision engineer and a runner. There is also an Avid editor working with another producer providing cut-picture content.

Who are the key people in your team?

In short, everyone is important. Everyone is there for a reason and if one person doesn't do their job properly the programme suffers.

Is there a script?

Yes. The producer writes the script over the week for the presenter to use on the day. A researcher will provide the background information for the script. The structure of the script is fairly formulaic – we don't deviate too much from the tried and tested.

Why?

It's a live event and we need to be sure that everything is under control. I believe the viewer gets used to certain conventions. Where we can be more creative is in the presenter's contribution and their personality.

Producing magazine shows

'I RELY ON PEOPLE TO DO THEIR JOBS PROPERLY. IF A RESEARCHER GETS THEIR FACTS WRONG IT'S NOT GOOD.'

What can go wrong?

Any number of things can go wrong. For example, the presenter can fluff their lines or say something unexpectedly, which could be libellous. The script can be wrong, I rely on people to do their jobs properly. If a researcher gets their facts wrong it's not good. Obviously in a live situation we can have technical problems. We can lose sound, vision or run out of time for rehearsal. Preparation is everything – if you prepare properly you can minimise your risk.

When it does go wrong what do you do?

Keep calm. The last thing you need is somebody shouting in a gallery. This only makes things worse as it tends to compound the first mistake. Nervous people make more mistakes. The producer and director in the gallery have to think on their feet and provide leadership.

This is also a people business and you need to be able to manage people to get the best out of them. A little encouragement goes a long way.

What do you like doing best and why?

Making good-quality programmes that are technically well made, thoughtfully produced and creative. I'd like the viewer to feel comfortable, interested and hopefully a little excited about what they are watching.

What do you consider to be the most important skills to have as a producer?

Patience. Whatever you have done in your career you are only as good as your last programme. You are constantly striving to improve and move on.

Did you have any formal training?

No I didn't. In the television business you tend to learn from experience. I believe the only TV company who offer formal training are the BBC. All the producers I have ever worked with learnt on the job. Most people start as runners or work in TV ops and basically work their way from the bottom up.

An example weekly magazine programme > Case study: The executive producer

LEARNING CURVES

The most effective way to learn how to be a producer is to get up and do it.

This final chapter looks at the ups and downs of making short films through the eyes of post-graduate student producers. In-depth interviews with the writers, producers and directors of short dramas and documentaries unpick the production experience from the conception of the idea through to post-production and delivery. All talented film-makers, they talk about the problems they faced, what they've learnt, and provide useful tips to other aspiring film-makers.

Films made away from the pressures of industry and commercial controls should give the up-and-coming film-maker freedom to develop, make mistakes and to experiment. It is hoped that these discussions will help and inspire other emerging producers entering the exciting and challenging world of production.

Breathing In
Breathing In is a short drama produced by Oliver Goodrum, one of the up-and-coming producers featured in this chapter.

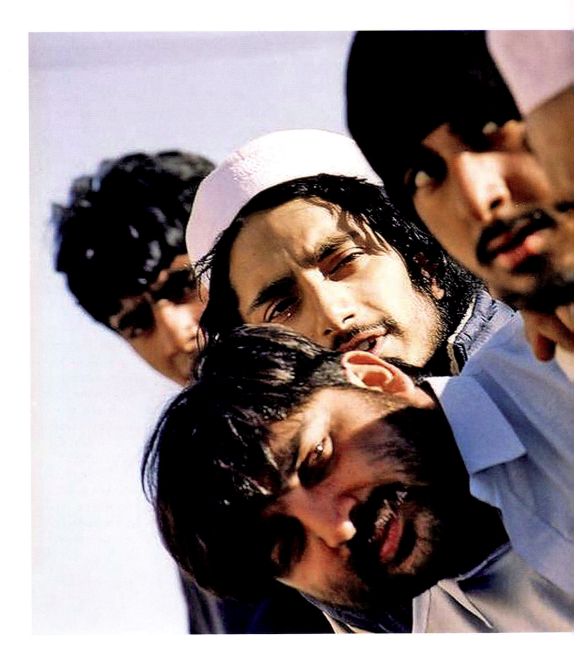

/ The Road to Guantanamo, 2006

Synopsis

The Road to Guantanamo is a docudrama based on the true story of three British detainees incarcerated at Guantanamo Bay Naval Base, Cuba. Through a combination of interviews with the three men and archive news footage from the period, the film provides an account of the men's experiences from their travels into Afghanistan to their capture and imprisonment at Guantanamo Bay. *The Road to Guantanamo* won the Independent Spirit Award for Best Documentary Feature.

Andrew Eaton

Andrew Eaton is a British film producer who has received many awards, including the British Independent Film Award Producer of the Year 2000 and the 2004 BAFTA Award for Best Film not in the English Language. Andrew Eaton works with film-maker Michael Winterbottom and together they formed Revolution Films in 1994. Their films, predominantly created with small crews and digital cameras, cover a range of genres including futuristic, Western, period and docudrama, and are characteristically provocative and challenging.

/ Oliver Goodrum

After graduating with a masters degree, Oliver entered the industry as a runner for several high-profile production companies. Having gained experience on features, commercials, music videos and shorts, he was offered a full-time job with a commercials company. He is well on the way to becoming a producer, and has worked on several film projects with new directors.

You did an MA in film-making and your final film was a drama. Can you tell me about the story and how you got the idea?

I always say that it is about a fat guy getting into a pair of trousers. I guess it is about people's insecurities and finding those insecurities in others.

The process of getting the idea off the ground to pre-production – can you go over that a little bit?

The idea came from a very small animation, a profile of someone holding their belly in. It all came from there really; how it feels to be overweight and how that affects your life. It sort of came about in bits and bobs; you do a draft and read, then work out the problems and fix it and then go from there. Obviously not all of the problems were fixed – it didn't quite work.

How long did it take to reach the point where the script was ready?

There was a date set and we pushed it back as far as possible. We had to shoot it and then make the film before we finished the course. Lots of people helped; friends who work in the industry that I'd met over the summer that I had done bits and bobs for. I ended up shooting the fourth draft of the script, which was not enough. I had people quote that John Hodge, the screenwriter for *The Beach*, did it in 50 drafts, and I think I would have liked to go through at least another six; I think that if I had done 10 drafts it would have been a lot better.

Once you've got the draft and you have the pressure for the deadline, can you talk about your role as producer in pre-production?

I think in the beginning I was really nervous and quite scared because I had never done it before, so I was just worried about everything and I didn't really understand that you sort of have to take a mechanical approach to it. One thing that I have learned here [referring to working at the film company] is that you take a call sheet from an old film and work from that. Then you start filling it in yourself including the equipment, where it is coming from, what equipment you are getting, how it is getting to the set, what time it is going to be there – that type of stuff.

Storyboards
Oliver carries out in-depth storyboarding as part of his preparation for filming.

You made the decision to shoot on film. Can you talk about the choice that you made because it obviously made an impact on production?

At the time I was lucky to be working at a production company and managed to get hold of some stock. So we got five reels of 16mm, which is 50 minutes' worth of stock – plenty to shoot on. The production company were going to give me some more stock from another production they were doing, but I went to the Christmas party and started speaking to the producer of a big TV drama production and I managed to get a whole box of stock from him. We had all of the equipment, and all of the locations were either at my house, a local women's institute (for the canteen scene), the bar where my brother was working or outside. We managed to get all of the locations for free. At the time we didn't have any money, luckily my dad decided to give us £1,000 and I added a further £500. So our budget was £1,500. We went over in the end – we probably spent about £2,000, but that allowed us to shoot on film. Amarillo [name of Oliver's production company] brought insurance to cover everything for the film and when we needed a dolly they were going to help with that, getting a proper [pee wee] dolly. In the end we went with a suitcase dolly, which was just easier and was all we needed.

What about finding your actors?

That was quite a scary process. We put up a posting on Shooting People, which in hindsight was a good thing, but I don't think it is the only thing you should do. I didn't realise about casting directors and things like that. To get a casting director on to a short film is quite a big task, especially for free. Through our posting on Shooting People we got loads and loads of CVs from girls, but hardly any from guys. We saw about five guys and I was happy with two of them. The guy I actually approached wasn't available, but luckily Matt was still available and in the end I think he was certainly the best choice – it was sort of lucky that the other guy wasn't available. In hindsight we were making it all up on the spot, but with the girls it was a lot easier because they had a lot to work on and as soon as I saw Sally, I knew she was the one for the role.

What do you think was the biggest challenge as a producer?

The biggest problem was inexperience, not knowing what I was doing and how to do things in the best way. In the end it happened and it went all right. On the day when we were shooting I was not working with the actors a lot of the time. I think the running of the shoot didn't go too well in my eyes, especially now, knowing how shoots go.

Was it because you were doing both roles?

On the shoot days I wasn't with the actors enough and now it is the only thing I do. But we just didn't plan enough and we were under-prepared. We did a storyboard but now I do animatics, cut my storyboard together with dialogue and know exactly if the scene is working or not – I think it is a massive help. At one point when we were in the office I didn't know what to do, I just couldn't function, I had a blank. Adam and Will shot some of the shots doing the Sellotape on the hands and the rolodex. I wasn't even there when they shot that because I was off trying to work something else out. Now I would never let that happen.

'IT IS ALL ABOUT PREPARATION. I WOULD HAVE DONE A LOT MORE DRAFTS OF THE SCRIPT.'

Learning curves

Now that you have some industry and producing experience what would you have done differently?

It is all about preparation. I would have done a lot more drafts of the script, more in-depth storyboarding and I would have cut that together to really work out how I was going to make the scene work. I would have done a lot more research in terms of lighting, the look of the film and how I wanted it to look. I think on the day I would have been a lot more prepared and worked with the actors a lot more. I would go for professionals because there are so many out there and there is no reason why you can't find some amazing actors to work on your short film. But going back to casting, I definitely do that differently now. Ideally I would try and find a casting director or at least a casting assistant, someone that is trying to become a casting director to help me. I would look at more people. I would also take a lot more advice from every single angle from as many people as possible throughout the whole process... I would do that a lot more.

What advice would you give to a student who wants to be a producer?

Get experience. Get out into the industry because it opens your eyes. Just learn as much as possible and get advice. Keep making phone calls, keep writing a list of things to do because you are the only person that is going to do it, and keep knocking on doors asking questions, asking people. People can only say no.

Working with the crew
Oliver recognises how important it is to work closely with the team in order to get the best possible results.

Producer greats: Andrew Eaton > Oliver Goodrum – Breathing In > Joao Tristao – Ambulance Blogger

/ Joao Tristao

Combining his experience as a journalist in Brazil with a post-graduate film-making course, Joao produced two compelling documentaries about life in London.

Tell me about the first film you made on the post-graduate film-making course.

The first film I made was called *Ambulance Blogger* about this guy called Tom Reynolds. The first thing for a documentary is that you have to have a strong character and then you can start the production. So I basically did the search online to find someone interesting, and I found loads of different things that appealed to me. Then I found this guy, Tom Reynolds, who writes a blog. He is in the top five in the UK, so loads of people read about what he is doing every day. It is a blog about his ambulance work, as he is a paramedic. The way he writes is really funny, a different approach to the story. So that is how I first got the idea.

Is your journalistic experience useful?

Yes, it is a different approach when you are a journalist. You're trying to think of something that is going to make the news, and I think this guy could make the news, he is different. I was trained to do that – to imagine the story before it has happened. To think about how best to target the story, how to approach the story.

How did you approach him?

It was really difficult, firstly because I was a bit insecure because I was a student. When I was in Brazil I was a journalist and I had a newspaper behind me. But I sent an email saying that I really liked his work and I asked if we could talk about maybe making a film, a short documentary. He gave me his phone number; I called him up and explained a little bit more about the project and he said that he had to talk to his boss from the London Ambulance Service. That was a bit complicated because I had to call his boss, explain the idea and get all the forms signed before I did the actual film. It was a little tricky for me because I had to talk to many different people from the [ambulance] service to get the permissions.

What was the process of research and production? How did you go about finding out what you could use in the film?

That comes to me naturally because of my journalistic experience. Firstly, I had to do the research about who this guy was – I needed to know everything about him. I needed to read all of his blog – it is a three-year blog! I read most of his work and then of course I Googled him and then I found newspaper interviews on him. He had a book coming out in a few months so I read all about that. You need to do the research before you go into the interview; you need to know who you are talking to. That is why it is called research. You gain confidence, especially nowadays with the Internet; I even found videos of him on You Tube, so I knew he was funny.

How did you plan out the filming, bearing in mind your journalistic background?

The basic difference is that journalism is all very basic; you just tell the story. With a documentary you need to get people in the mood to talk about the subject, but the first thing that caught my attention to the story was the way he wrote. He often made fun of some of his patients because they call the service for minor problems, such as having something in their foot that is hurting a little bit. Basically what he says is that people are lazy so they call an ambulance, they are not actually sick. So I thought that after everything I read about him on the blog, that bit was the most interesting. I didn't want to tell the same story that people have told before; that being a paramedic is tough, emotional work.

My filming plan was that filming should be based around two spaces; the Internet blog and the ambulance. I decided it was a good idea to start filming at his place first so I could get to know him better. You need the first day of filming to get to know the person, especially in a documentary where you are not really directing the person, you are kind of following them. There has to be a trust between the two of you.

Ambulance blogger
A screengrab from the blog site that first attracted Joao Tristao to Tom Reynold's story.

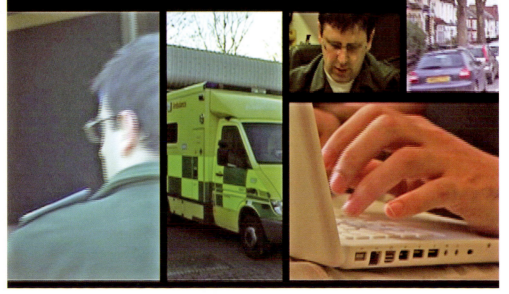

the ambulance blogger

It was a five-minute film. How many days did you shoot?

My first idea was to go to his place, to spend half a day over there just talking to him. I had loads of questions so that I could get to know him better. It's also an opportunity to get to know the story better because when you ask questions you may get a response that you weren't expecting. That is the nice thing about doing a film. By having a break between filming you can actually think about and re-watch the interview.

When I visited him I had a bit of a problem because it was around November or December and he was really busy at that time. I didn't get permission to film with him in the ambulance until a month later, after I did my first interview. That really concerned me because if I didn't get the ambulance then there was no film, as I needed to see the people coming into the ambulance. That only happened a month after and we only had one chance to film on the ambulance because he couldn't do any other day.

How long was that day?

The day was 14 hours. I felt bad because he never stops. He only went back to the main station once to have a cup of tea spending only five minutes there, and then he had to go back. I had to stay all day on the ambulance with him, all day long holding the camera. And I knew it was such a tight space at the back of the ambulance. It just was me with Anita [crew member] helping me out.

What was Anita doing?

I was filming non-stop with the camera. Anita concentrated on getting permission from the patients. So I would stay with the camera and focus on Tom all the time, and Anita would get permission from the patients. She would enter the ambulance to talk to the patient to get their permission and I would wait outside. If the patient said OK, I would jump on the front.

But you also would have written consent forms?

Yes, we got forms from everyone at the end, including the hospital staff.

Permission from the local hospital. Can you describe the type of people you had to approach?

You need to know who you need to talk to; sometimes that is a difficult thing especially in the London Ambulance Service. Firstly there was Tom and Tom's boss because he was the manager of that station. Then Tom's boss told me to talk with the Communication Office for the London Ambulance Service at home, and that is what I did. I explained the idea and so forth and then they gave me all the permission that I needed.

How many hours of footage did you shoot?

Eight tapes.

You produced and directed, how did you approach the edit strategy?

When you are filming you really have to think about the edit. So when I was filming I already knew which patients I really liked so that helped me out. Then when I got home I would watch all the tapes again and then I would paper edit. So I didn't digitise all my tapes because it would be a waste of time. I would only digitise the good patients – five or six patients in total, and then I started out with the ones I really liked the most, like a guy who took a lot of painkillers. I knew that that was really strong so I started editing his story first. I constructed his story then I would do the same with three or four other patients. Then I would re-watch the interview that I did at his [Tom Reynold's] place to try to see what they have in common, trying to match things. Trying to get the feeling of his work. I guess what I was trying to do was a video blog – the same thing Tom does in writing but on video.

If you had to make the film again, would you do anything differently?

Yes, I think you always wish you had done something differently. If you had the chance to go back you would always do more. I think that the film lacks a little bit on the Internet and blog side of the story. I needed to persist more with him, to go back one more day, but sometimes the person says, 'Oh no, I am sorry I can't.' You have to be persistent sometimes and I felt that I wasn't. Sometimes, when you spend the whole day filming, you just want it to be over. You need to persist to make a good film; you need to believe in it.

Ambulance blogger quote
Joao was impressed with Tom Reynold's humorous and alternative approach to his blog site.

"I do like some people, although I often moan about the idiocy of others driving when faced with a big white van with blue flashing lights on top"

Oliver Goodrum – Breathing In > Joao Tristao – Ambulance Blogger > Daniel and Jesse Quinones – Cage Fighter

/ **Daniel and Jesse Quinones**

The Quinones brothers are originally from Miami, Florida, but now live in London. They run their own production company, Woolfcub Productions (www.woolfcub.com) which specialises in documentary and drama. They have already received several awards and nominations including 'Best Documentary', at the International Student Film Festival Hollywood.

Can you talk about the first documentary that you made? How did you get the idea and carry out the initial research?

DQ: I guess you could say it came from me. I said I would like to make a film about cage fighting, but we were both interested in it to some extent. It is a growing sport at the moment in the United States and it has been for a little while, but it is an underground sport. We decided to make a documentary about that.

JQ: It was a tricky situation because we needed to come up with something to meet the deadline for the course. The day Danny came up with the idea we called the Cage Rage Organization and talked to the PR department. They put us in touch with the promoter and he said, 'Come to my next training session tomorrow night and I will introduce you to three fighters and you can take your pick'. So the next day we went to the meeting, to the training session. We brought our camera with us and filmed the training session and also filmed the three fighters doing a preliminary interview. We needed to decide who we wanted to dedicate our film to.

DQ: Who would be an interesting enough subject to sustain the film for us and would have enough character that would come across on the screen. I guess not the kind of stereotypical fighter that you would normally expect to see. So we went with the guy who was the least stereotypical fighter. Probably the one out of the three that you would expect least.

'WHEN YOU SEE SOMEONE TOO COMFORTABLE ON SCREEN... THEY BECOME LESS INTERESTING.'

Learning curves

So what would you say was the key element of that character? What were his attributes?

JQ: I think the thing about him that really appealed to me was that in a way he almost seemed a little uncomfortable. When you see someone too comfortable on screen, enjoying the camera, they become less interesting. The guy was sort of shy and a bit introverted, because of that, every time we caught a moment with him it almost feels like a discovery.

DQ: We are discovering a moment. Yeah, you have to wait until his guard is down and that is the moment when you get the best stuff.

Once you found him what was the next stage in pre-production? What was the time scale and what did you have to deal with so you could film?

DQ: Basically he had a fight the following week. We had to make a decision whether to film him that week or wait three months when the next fight came up. We decided to go for it. We could still make the next fight anyway, so we decided to film this one and learn from our mistakes. We could always make the second fight if the first wasn't any good.

So you only had a week?

DQ: A week to shoot the entire film apart from a couple of shots that we did afterwards, but we did it in a week in terms of shooting.

What clearances and access did you have to seek out?

JQ: A lot of the stuff was done with the promoter. We obviously had to have clearances with Dean Gray, his girlfriend, his friends and the promoter, and also a location permit. There was also an agreement not to film the fight itself, but we would be able to use the footage of the fight. This was because he owned the copyright to the fight and he didn't want anyone else to film it.

Was there anything really problematic?

JQ: When we first found out that we wanted to film Gray he warned us that we would have to pay for the permit for the location. That sort of alarmed us because we would have a documentary about the fighter and not actually have the fight.

DQ: And basically we wouldn't get the fight footage until very late. For editing purposes we didn't actually know what they had, and as that was the main part of the film we were kind of unsure about the situation. We had to sit there and wait maybe a week and a half before we had to hand it in, which was very close to the deadline.

'DOCUMENTARY IS UNPREDICTABLE AND SOMETIMES IT IS ABOUT CATCHING THE RIGHT MOMENT.'

In a way it doesn't seem to matter because this footage is only part of the story?

DQ: The fact that the fight wasn't very exciting was a bit of a let down so it was kind of an anti-climax.

How many days did you have to shoot?

JQ: Seven days. We had two training sessions; we had one day at his house and one day at his job.

How long were the days?

DQ: The training days were about three to four hours. At his house we spent about four hours. (The job) was at five o'clock in the morning and that was a bit of a pain but we were only there for about half an hour.

JQ: In total we shot 15 hours. We wanted to be able to make mistakes. If we shoot everything that we think is relevant we have it, so in editing we felt comfortable sitting through it all.

Were there any mistakes and have you learned from them?

JQ: There were a few technical mistakes because the camera was new to us and we shot the first day on 32 K – you don't notice those little mistakes. I think there is a tripod in one of the shots as well. We incorporated more of the techniques we learned towards the end of the film for how to disarm the interviewee. We did a few things just to relax him to make the interview less formal and let him know when the camera was on or off. The last footage was some of our strongest material.

Because he was comfortable?

JQ: Yes, he didn't know he was being interviewed, we were just having a casual conversation and we used a lot of that. We filmed him at first and then we turned the camera off and started talking to him and then Danny would turn the camera back on.

With the pre-production is there anything that you feel you learnt?

JQ: I think with this one, because it was so fast paced, the thing that we learnt was that sometimes – which I think is a good thing – it is always good to be prepared, but sometimes it is good to be a little spontaneous, to go with your gut instinct. Documentary is unpredictable and sometimes it is about catching the right moment and finding the magic in it.

For post-production, how long did it take to edit? How did you approach the edit?

DQ: The challenge in the beginning was really just finding the story because we had all this footage and we needed a structure; I think this is really difficult in the beginning. What we did was we started with the intro by creating little scenes. We tried to keep the same standard of quality in all of the scenes throughout the entire film. The next scene is only as good as the one before. We had to edit the film in one week because our grandfather passed away and we had to do a 60-hour week in five days, so it was interesting. That brought out something different for the edit.

Do you have an overall tip for someone making their first documentary?

DQ: Not to get too consumed, too focused on the technical parts of film-making. It is very important to know them all, but sometimes people get a little obsessed with technical things. It is more important to get a good idea, a good story and a good character.

JQ: And if you have those things people will get engaged with the material and won't notice that there is something a little bit off, like the sound or lighting not being quite right. They won't see it because they will be so moved by what they are watching. Make something from your heart.

On a practical level the camera was a PD-150. Did you use boom or radio mics?

DQ: Boom and it was edited on Final Cut Pro.

And lighting?

DQ: No lighting at all.

So that was it? That was the equipment?

JQ: For the budget it was just £5 travel.

Can you talk about the idea and its development for your project *Cold Calling*?

JQ: The initial idea came about a year and a half ago. I was in the writer's group, the Royal Court Theatre, and I had a short play called *Cold Calling* based on my experience working in telesales for the past few years. The challenge was that it was all set in a room – we felt that visually it wouldn't be that interesting.

How did you make the transition from play to film?

DQ: It was a challenge; it is quite difficult because you think that if you shoot it straight up it just won't work. It's weird what works on stage, but doesn't work on screen.

JQ: You have to figure a way to tell the story in pictures.

How did you approach pre-production?

JQ: With this one, especially after making our first drama, I think we were much more prepared with the pre-production aspect. We started scouting locations while we were still developing our script because we knew it was going to be set in an office and we had to find a location that was within our budget. We also found some crew members that we thought would have a good contribution: an assistant director, sound engineer and a production designer who were willing to come on board. In addition to that we auditioned actors. All that was happening while the script was being developed. The script went through about 12 drafts and even after that it still changed while we filmed on the day.

DQ: And even now we are still changing it, cutting it down trying to make it shorter.

How did you find the location?

JQ: We did a lot of research on the Internet. We telephoned people to find out if they were renting out offices. At first it was tough because, although we had a budget, we couldn't find anybody who would rent out for a temporary amount of time. Everyone wanted to do a six-month lease, and when we said we wanted it for three days they were not willing. We looked through a lot of places on the Internet, spoke to a lot of people and then we found one guy who had a lot of space that he didn't use for anything, so we rented it out for a week. We filmed for three days, but we wanted to dress it up and have one day for the actors to rehearse. We rented it for five days at a cost of £100 per day.

What about the other locations?

JQ: One was the production designer's house and the other was our house. There were two locations, one was in my room. We filmed it like it was two different places.

And the actors?

One of the actors we found through a tutor at the university. One I know from the theatre, and I played a cameo. Daniel's girlfriend also played a cameo, and a friend of mine played a little part in it as well. Some were friends and others were actors.

How long was the shoot?

JQ: Five days, but it wasn't five full days. There were three to four days in the office and then two half days, which could have been one day, but it was at a different location. Technically probably four days.

Did you have issues with the actors, budget and getting people on location?

DQ: Because we had to shoot it through the week a lot of people have jobs, so we had to work around people's schedules in terms of the crew and actors. It was quite difficult.

JQ: We did have to drop an actor for the part of Will. He was a guy who we worked with before, we liked him and he was in our previous film but his schedule conflicted so we had to let him go. And then we were really concerned about the two cameo people in the bed scene so that is why I did it myself.

DQ: And my girlfriend had to do it as well because basically people weren't willing to give up a day, especially actors, because they wouldn't want to do such a small role without getting paid.

I think that is one of the challenges of making a low-budget film?

JQ: But I thought it was kind of fun with regular people. I think actors are good but sometimes they get too excited and people are more authentic sometimes.

Any unexpected issues with the shoot?

DQ: Some of the issues were that at times different people had different opinions on the way things should go. When there were different visions the script got written between us, but people sometimes forget and they don't actually know the script fully and so they don't understand the point. They don't know why certain decisions are made.

What would you have done differently?

JQ: Been more stern and executed exactly what we wanted instead of letting our crew get out of hand. It was a young crew of 21- to 22-year-olds, who were a bit immature. But after the first day we became a bit stronger because we were both kind of upset because we messed up a shot. Our assistant director lost the plot through the whole excitement and just didn't check it off the shot list so we basically missed the shot, but we worked around it.

Any other problems with the production?

JQ: Nothing technical, but I think both of us agree on the lead actor. He was a very good actor but we had a very specific idea about how the pace of the film was going to be and how it was going to be performed. In our heads we both saw it as being a very fast-paced film and I think he kind of always wanted it to be more realistic.

I think his performance works, but within the film the pace is a bit slow and I think part of that is because it is lacking that heightened energy. Because he is the main character he is the pacesetter for the film, but the film is a bit slower than I would have liked. We did say that we wanted a quicker pace, but we probably should have persisted more.

DQ: It was the exact same issue with the bed scene. We didn't put our foot down by explaining to the actors that we knew they felt uncomfortable doing it this way, but this is the way the film has to be and this is the way we see it. We see the big picture.

Did you have any sound problems?

DQ: No. We played it safe. We recorded the sound twice with the boom mic and radio mic so if anything went wrong we always knew that we had a quality boom mic that is really reliable. No matter what happened we knew we would have some sound.

So the shoot was problem free?

JQ: More or less. It was very smooth and the actors overall did a good job and the crew worked very hard.

Going on to post-production, how many hours did you shoot?

JQ: About three and a half hours.

How did you approach the edit?

DQ: Basically, we edited the shots that we wanted, very crudely – just the shots. We had a finished film, which was put together very simply by popping shots on the timeline and looking at angles that we thought would work out at that point. It was a simple edit, very straight up with no creativity whatsoever. We just saw it how it was. And then we kind of went into it, started filtering it and adding little bits every time we edited. We went over it and then we would go back and sharpen the edit one more time.

How long was the edit?

DQ: About two weeks. We will probably put another week or two into it.

Do you have any useful tips on post-production?

JQ: Have a strong vision, but at the same time have a loose approach so you are flexible because something might not go the way you wanted it to. Work with what you have. I think you can make something nice or special if you have that approach. Have a strong purpose behind whatever you do, but also have flexibility.

Any other tips?

JQ: Find good people to work with and if you don't find those people don't be afraid to work with a small number of people.

DQ: You don't need to make a film like everyone else makes a film. You don't need all the things a big-budget film needs. You can do four roles if you have to, and you can edit on a laptop. Don't worry about other people's standards, just whatever you need to do to get it done.

JQ: As long as you have a creative idea and passion.

DQ: Don't focus on how you think things are done, but on how you want to get it done. Do whatever works for you.

Cold Calling
Production stills from Daniel and
Jesse Quinones's short drama.

Daniel and Jesse Quinones – Cage Fighter > Daniel and Jesse Quinones – Cold Calling

The successful producer, whether working on a digital short or a long-running broadcast TV drama series, needs to be talented, hard-working and committed. Alongside vision and creativity, the keys to effective producing are preparation, planning and quick thinking. Many of these skills come through experience and ultimately the only way to acquire the know-how of a producer is through on-the-job experience and by making a film. For many first-time producers and film-makers those first films are fuelled by high hopes, which are rapidly grounded by harsh practical realities. The learning curves are huge, exhausting and often scary. By setting down the ground rules and basic industry procedures, this book has attempted to outline the essential information, starting points and pitfalls that an emerging, inexperienced or student producer needs to keep control of.

As well as relevant practical tips and information to help the emerging film-maker, this book has set out to explore the different types of producer that can be found in the industry. It has also looked at how different forms of content are produced – from development through to delivery – allowing the novice film-maker to get a better understanding of the production process.

Rapid developments in technology mean that the industry is evolving, having to adapt quickly to the requirements of its potential audience. The traditional ways of viewing are being pushed out by new platforms and delivery systems, where the viewer is now very much in control. Despite this rapid change, one thing remains clear. Within this evolving global media revolution, content and programmes still need to be made by talented people led by savvy and inspired producers.

It is hoped that by the end of this book the role and responsibilities of the producer have been made clear. Fundamentally, the seasoned producer not only leads, but is part of a creative team, knowing when to step in, when to step back, and crucially, when to let talent blossom.

The producer
To be a successful producer requires talent, hard work and commitment – as well as the ability to juggle multiple tasks all at once!

Above the line the costs to make the film. These include the script, producer, director and main cast and are usually paid as a flat negotiated fee.

Aspect ratio the size of the screen image.

Below the line all the costs to technically make the film, including material costs, music rights, publicity etc. Usually paid on a weekly or daily basis.

Berne Convention international agreement regarding copyright.

Broadcaster an organisation that distributes programme content to a public audience. Eg the BBC, Sky and ITV (UK), ABC (Australia), Canal+ (France), CBS (USA), SABC (South Africa) and NHK (Japan).

Call sheet a listing of which actors will be required for which scenes, and when they will be required.

Clearance written permission, which can include the rights to script, music, location, actors and contributors.

Commissioning body an organisation that offers finance and support to programme makers. Eg (in the UK) Channel 4.

Distribution markets for selling programmes.

Editing the creative process of putting shots/footage together to create the finished film.

Equity a trade union for actors. In the UK, an actor must belong to Equity before being allowed to perform in any 'legitimate' theatre or film. Similar organisations exist in other countries, but because other organisations often exist membership isn't as essential.

Exhibition places to screen in front of an audience.

Gallery production control room within a television studio.

Licence/permission a document that outlines the terms/fee for using music or footage in a film.

Live transmission (TX) a programme broadcast to the audience as the event happens. Eg Football matches, royal events, etc.

Log line a short sentence that summarises the programme or film.

M and E Music and effects track, separate to the dialogue track.

Music cue sheet lists and timings of all music used in production.

Non-linear editing computer-based digital editing system that allows footage to be edited and manipulated at the click of a button.

Pitch a short description of a programme idea.

Post-production work performed on a film after the end of filming (production). Usually involves editing and visual effects.

Pre-production arrangements made before the start of filming. This can include script editing, set construction, location scouting and casting.

Press kit publicity package, which includes relevant information for a film.

Production the stage during which filming occurs.

Programme format a packaged programme idea such as 'Big Brother'.

Proposal an outline document that includes a description of the project, its intended audience and why it should be made.

Public liability insurance which covers the production company against claims for injury or damage to property.

Recce pre-shoot visit to a location to assess its suitability for filming.

Researcher person who identifies key contacts and sources, and will verify information relating to the programme.

Rushes unedited footage.

Script the written plan and dialogue for a film or programme.

Seed money money for development, which may have to be paid back.

Shooting script the script from which a film is made. Usually contains numbered scenes and technical notes.

Sting a very short visual used between features or other items.

Strapline also known as lower thirds, these provide information that is placed towards the bottom of the screen, usually to identify interviewees.

Transcript the finished programme including dialogue and interviews.

Treatment a description of the documentary outlining the story and contributors while conveying its mood and tone.

I would like to thank all the producers and film-makers who allowed me to use their work and experiences in this book. Also special thanks to Jane Barnwell and Chris Downham for their advice and input. To Camilla Boschiero for research, translation and transcription. To Phil Crean and Jack Evans for their help. At AVA, thanks to Brian Morris and Caroline Walmsey, and finally to Lucy Tipton, for her advice, patience and support at all times.

Picture credits

Page 3: Director: Oliver Graham,
Producer: Camilla Boschiero,
Photographer: Luigi Bertolucci
Page 10: © Getty images
Pages 13, 51, 56 and 57: Oliver Goodrum
Page 21: Louis Downham
Pages 22, 23, 24, 25 and 49: Mickey Liu
Pages 26, 27, 36, 92, 137, 138, 141, 143 and 145: Images courtesy of Chris Downham
Page 38: Universal/Jewel/The Kobal Collection
Page 41: © Serg64
Pages 44, 45, 46, 86, 88 and 89: Joao Trisato
Page 53: Artisan Pics/The Kobal Collection
Page 61: Courtesy of Robert Szmigielski
Page 62: Courtesy of Trick Dog Productions
Pages 66, 67, 85 and 96: Director/Producer Zoe Papadopoulou
Page 68: Portrait Films/The Kobal Collection
Page 71: Zoe Papadopoulou
Pages 72 and 73: Daniel and Jesse Quinones
Page 86: Joao Tristao
Page 90: Roberto Napoletani
Page 93: Charlotte Worthington
Page 98 Radical Media/The Kobal Collection
Page 115: Courtesy of aimimage
Page 123: Courtesy of The Film Office
Page 128: © DeshaCAM
Page 130: © Getty Images
Page 133: © Getty Images
Pages 134 and 135: Jane Barnwell
Pages 148 and 149: CSI Sports Trading Limited
Page 154: Revolution Films/The Kobal Collection
Page 173 © ChipPix